The Exotic White Man

Cottie A. Burland, 1905-

Photographs by Werner Forman

The Exotic White Man

An Alien in Asian and African Art

McGraw-Hill Book Company New York

© 1968 Verlag Anton Schroll & Co, Vienna and Munich

First American edition 1969

All rights reserved

Library of Congress Catalog Card Number: 71-87834

Printed in Austria by Christoph Reisser's Söhne AG, Vienna

09096

Contents

Introduction

Our reason for writing this book is that we are human, belonging, as we do, to a particular group of the human family. It will never be completely understood why it is or how it came about that the family of man falls into its various categories of blood grouping, physical appearance and language, but it has become abundantly clear that we are all members of the same group. In this modern world, events have universal repercussions, and we can no longer afford the dangerous luxury of separateness, nor may we disregard our differences. We must accept one another, striving to avoid bitterness and bloodshed in our inevitable family quarrels.

We were not always so divided, but as our progenitors spread over the earth, our common inheritance gradually became subordinate to differences of race and nationality, and to our varying social achievements, themselves reflections of different rates of progress in the common fight for control of the forces of nature. In the period which this book covers we find the various nations of Europe setting out on a path which was destined to increase the material wealth and the physical control of natural forces of all peoples, but these Europeans, with their ships and guns and the wealth these brought them, were deluded to some extent by their material accomplishments. As the history progresses we find them becoming increasingly self-centred, increasingly busy inventing excuses for their activity, and increasingly sure that they alone had the true knowledge of civilisation. In a word, they became arrogant and this led them into grave error in their treatment of their fellow humans.

However, when we look down the long vistas of history we find that other peoples in their turn have been in the position of world leadership. In time, these nations lost their power, and their accomplishments are relegated to the museums and histories. There are records of cultural contacts of long ago which tell a similar story to the one in this book, but now we concern ourselves with the developments which followed the efforts of the Portuguese Prince Henry the Navigator to find a way beyond Africa. It is, on a world scale, a narrow field, yet it covered the whole earth in its four centuries

of growth. It was but a sixth of recorded historic time, but it was a period which changed the face of the world and paved the way to the great technocracies of today.

In the four centuries of European expansion in the world there was an immense variety of human contacts: explorers and adventurers desiring above all to contact new lands and their inhabitants; traders anxious to exchange their commodities (and often, shamefully, recruiting and selling slaves); missionaries trying to teach the Christian religion to their less enlightened brethren, and too often confusing the ways of the white man with the Will of God; planters, sailors and settlers; and finally came the days of colonial rule with the white man the dominating power in a less technically advanced society.

On both sides there were atrocities and injustice, mostly due to false reasoning, ignorance, and more terribly to the juggernaut of mindless economic pressures at home. The old fears of the evil consequences of corruption brought about by a man's acquisition of power over his fellows are as true of Chaka the Zulu as of Genghis Khan or Atahuallpa Inca. Yet amid all this turmoil human beings expressed their own feelings through art.

Art may be conditioned by the feeling of the time, as today in the experiments of a world which seems on the verge of self-destruction. Yet art is also the creation of individual experience. Leonardo knew the woman who sat for the Mona Lisa, and he used his skill to interpret her personality. We know her today. In the same way nameless artists, working in non-European traditions, saw Europeans and recorded them. And in viewing these works we can see that the artist has interpreted more than just form and feature; unconsciously he has revealed the impact on his own soul of this contact with another person from a distant land.

Owing to the perishable nature of wood and pottery, much of the art which we reproduce in these pages belongs to the late eighteenth and nineteenth century, but probably it was always similar in content. It is rarely a serious exposition of the evils

I A Portuguese nobleman dining with a lady of rank. Note how the Portuguese has adopted some of the more comfortable clothing of tropical Ceylon. The carvings surrounding this centre panel are symbols of good fortune and illustrations of popular fables. Ivory casket decorated with jewels, from Ceylon, *c.* 1540. Schatzkammer of the Residenz in Munich (No. 1242)

8

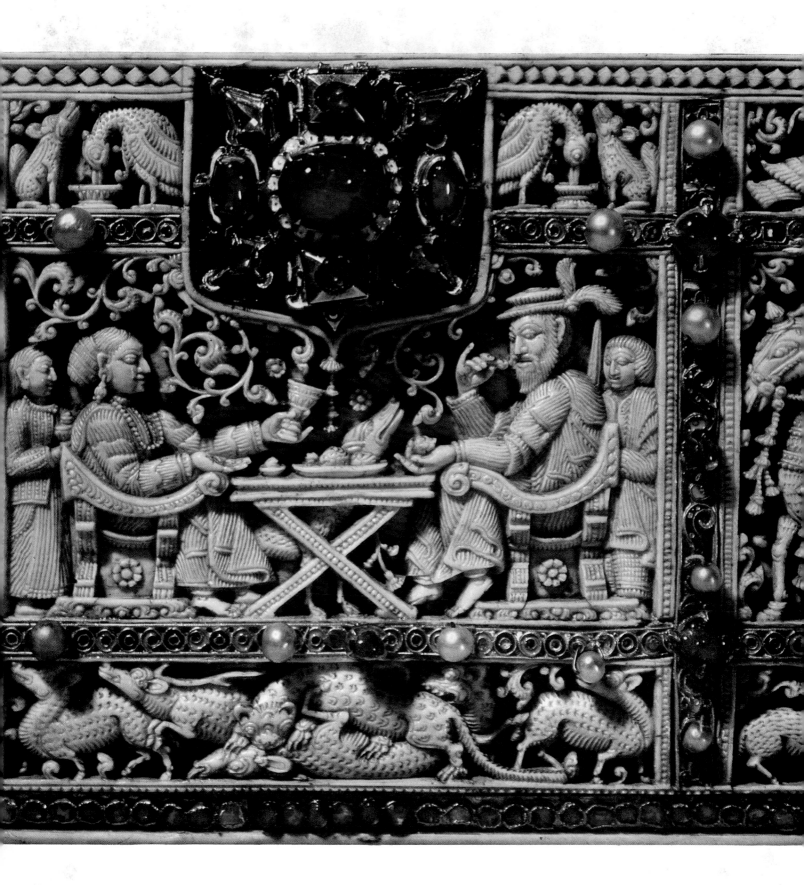

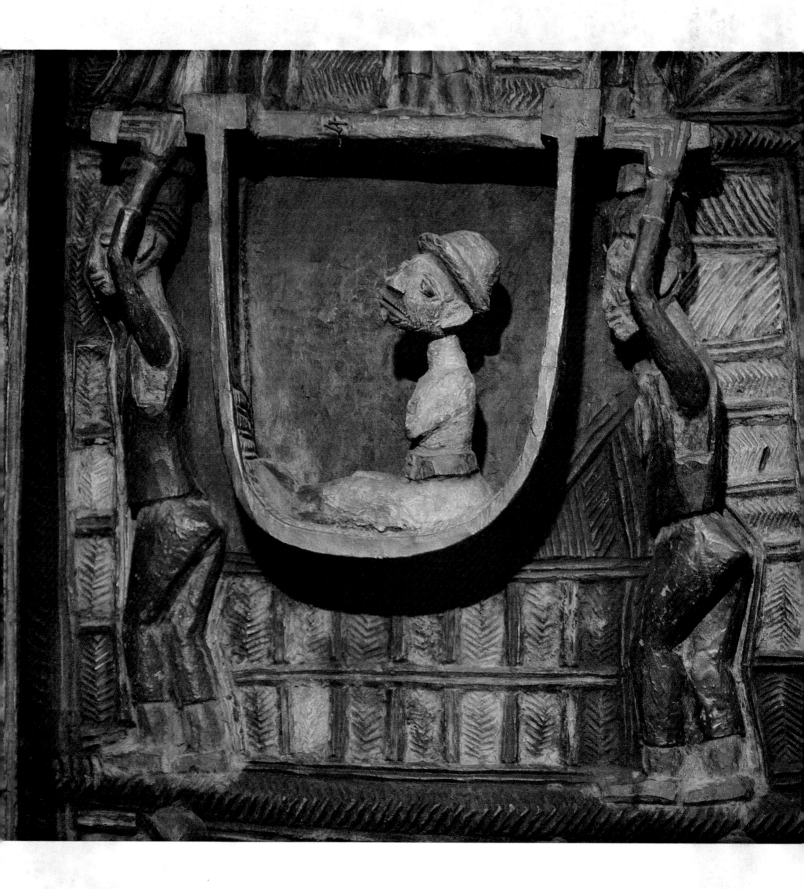

inflicted by the strange people, rarely even a tribal expression of suffering. Mostly it is a view taken by the artist. In many ways the artist is imbued with the traditional forms acknowledged by his tribe as the best. His attitude is likely to be less personal, as contact with the white men was rare, and his ideas were usually the result of market-place discussions with friends. Only in the later times do we find indisputable portraits, such as the gay little works of Yoruba carvers in Lagos, Nigeria.

The artist is somewhat prone to see the foreigner as a comic creature. Our features were odd, our pinkish colour somewhat revolting, our kinder moments endearing. And this was how we were seen, odd creatures from far away who were sometimes quite charming, and sometimes hatefully cruel. In this book we shall have to take ourselves as others found us.

II The art of travelling in the African bush. This carved wooden panel from the palace doors of the Ogogo of Ikere Ekiti, in southern Nigeria, commemorates the arrival of the first District Commissioner, Captain Ambrose, in 1895. Yoruba people, carved by Olowe of Ise *c*. 1900. British Museum, London, acquired 1925

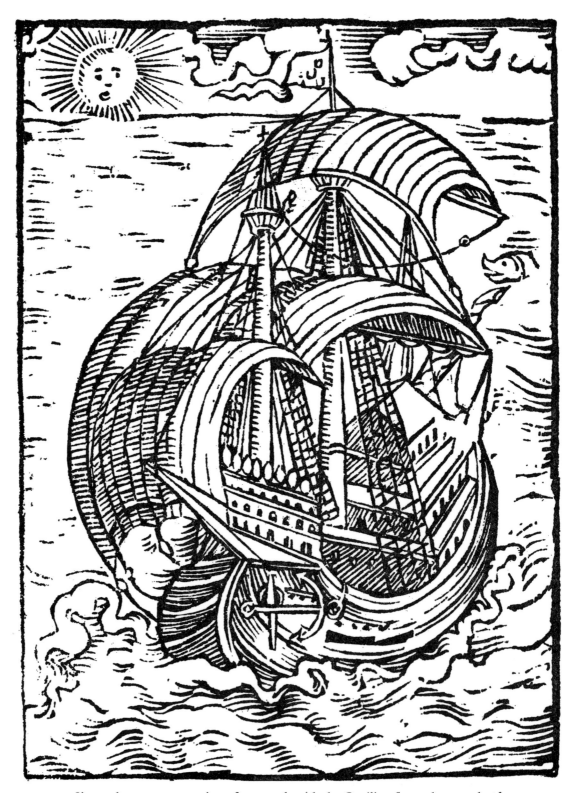

Sixteenth-century engraving of a caravel, with the Castilian flag at her masthead

The Explorers of the Ocean

In the mid-fifteenth century the world was in a very different political state from that of recent times. The nations of western Europe were rapidly becoming independent monarchies, at war with one another, yet just beginning to understand the possibilities of obtaining new riches from commerce. In Spain the various states were on the point of uniting, and the last Moorish kingdom at Granada was in a comparatively weak position. True, the culture of the Moorish states was still richer than that of the Christian countries, but there was evidence that the westerners would soon catch up. In the East it was clear enough that Byzantium, heiress to the vast imperium of Rome, was old and weakened by the incursions of the Ottoman Turks. In fact it was the Turkish empire which was the great military force threatening the existence of European culture. The immense power of its well organised armies, and in particular its heavy artillery, dominated the eastern Mediterranean. Western Europe was isolated. Long ago the rich countries which had been visited by Marco Polo had faded from the minds of the common people. Beyond the walls of Turkish steel there might still be the Christian kingdom of Prester John, but to pierce that barrier was a vast problem.

Gradually it became apparent that if Europe was to survive, in spite of its limited culture when compared with the Islamic world, some new opening would have to be found by which the rich world of commerce and perhaps of military might beyond the Turkish dominions could be reached.

It happened that the small kingdom of Portugal was to show the way to a new development in Europe which was to have the most remarkable consequences. The impetus came from Prince Henry the Navigator, who encouraged the sailors of his brother's kingdom to extend their explorations southwards along the coasts of Africa. During his lifetime they had hardly turned the curve of the coasts of Senegal and Gambia, but they had discovered a base beyond the Canaries, and begun to contact the lands of the dark-skinned peoples beyond the Arabs and Berbers.

In 1445 Henry heard that Zarco had rounded Cape Verde, and although internal

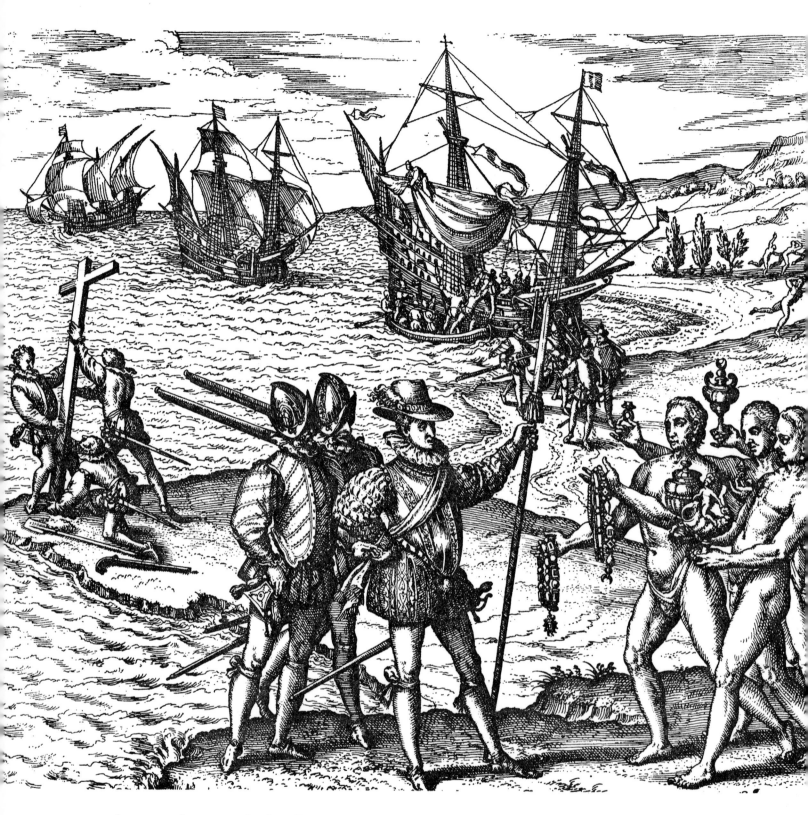

A seventeenth-century print from Dapper, representing the arrival of Christopher Columbus at Watling Island

struggles in Portugal occupied his later years, in the year of his death it is probable that Portuguese navigators had reached Sierra Leone, the land of the Lion Mountain. This was important because it brought Europeans in direct contact with Africans who were not already greatly influenced by Moslem culture.

There had already been a little fighting, for the African village chiefs had not always welcomed the pale strangers. A number of Africans from the Gambian coast had been taken to Portugal, and at first the thought was to use them simply as labourers, but the government did not like the idea of treating these strangers as prisoners of war. Some of them were obviously acquainted with carving and weaving, and they were taught the artistic skills of the renaissance culture in Portugal, though it is to be noted that the white men seem to have preserved pieces of ivory carving in truly native style. There was not much discrimination, and indeed the villager on the Gambia was not greatly different in culture from his fellow who was a peasant on the Douro. However it was not too long before less scrupulous sailors began to think of the land of the Negroes as a source of unskilled labour. Slavery began again in Europe. It was condoned on the score that the antique civilisations had employed slaves, and that in any case the Bible enjoined masters to treat their slaves well. It was not vastly different from conditions in the Arab world where slaves were employed under the traditions which the fifteenth century had inherited directly from the classical world. In Africa south of the Sahara the great kingdoms of black Africa struggled to extend their boundaries, and in the process many slaves were taken and sold.

As the Portuguese continued their slow progress along the west coast of Africa, the Spaniards were preparing to set out on a still greater adventure westwards. Some portions of America had been discovered long before the time of Columbus. Certainly the Norse voyagers who had settled in south Greenland had travelled far along the coastline of North America, but had concluded that it was an island. Indian hostility had precluded any mainland settlement by the Norse, but there were regular journeys along the coast to obtain timber and furs. Bishop Eirik Gnupsson preached to the natives in the twelfth century. In the fifteenth century the map now known as the Vinland Map was inserted into an account of travels in Tartary. It seems that the compiler was under the impression that these lands were simply islands off the coasts of

Asia. Indeed, the general opinion of the age accepted this.

It was reasonable, then, for Columbus to think that if the rich lands of Cathay and the Spice Islands were to be discovered, the Atlantic Ocean must be crossed much further south than the fishing grounds off Markland (or Newfoundland as it was later to be called). He also shared the idea of his period that the Earthly Paradise was to be found in south-east Asia, in the area now comprising Laos, Cambodia and Vietnam. Hence the idea he presented to Her Most Catholic Majesty, Isabella of Castille, was that the Spice Islands were to be found by sailing across the Atlantic towards tropical latitudes. He was firmly convinced that this route was also to lead to the Earthly Paradise. No doubt the story of Columbus and the egg is a garbled reference to the concept that the Mountain of Paradise was a part of the earth which almost reached Heaven. In fact, Columbus's proposition had been passed from one nation to another before the Spaniards showed interest. The country was at the time harassed by the final war to oust the Moorish rulers of Granada, and Queen Isabella was obliged to borrow money for the venture. She requisitioned two tiny ships, press-ganged a crew, mostly of convicts, and backed the famous first voyage.

What was discovered was an island inhabited by simple, naked villagers, who worshipped ghosts and thought the white men were divine personages. One notes that in each subsequent voyage Columbus swept further south, apparently still searching for the Earthly Paradise. On the voyage which brought him to Trinidad he found the native peoples wearing coloured cloth turbans. More than ever he became convinced that he had found the Spice Islands close to the Indies; these people could only be Indians. His next discovery, the great stream of fresh water surging deep into the ocean from the mouth of the Orinoco, confirmed his conviction. Surely this must be one of the rivers of Paradise. Columbus died in the belief that Asia had been reached. It is ironic that his Earthly Paradise was so soon to become a place of terror and exploitation of human life.

The West Indies were early settled. The idea was to divide the land into productive estates which would be worked by the native peasantry. Gold was to be mined and sent to the homeland, while the farms were not only to be self-supporting but to produce sugar and spices for export. It was an excellent scheme—if only the neolithic inhabitants had understood what was required of them. The tales of the treatment meted out to them

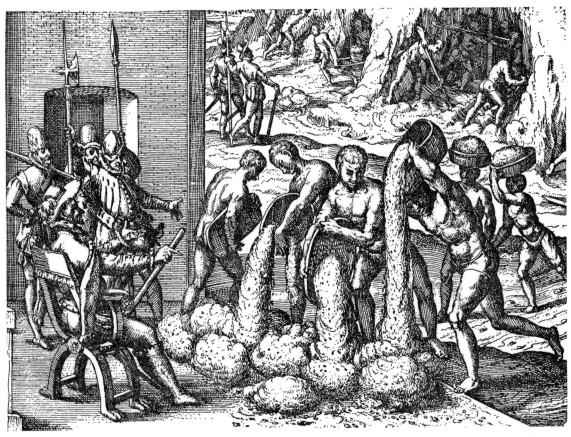

Seventeenth-century print from Dapper, showing the exploitation of the Indians of Hispaniola

by the early settlers in their efforts to organise the natives, make painful reading, even in the present age of atrocious wars. One does not idealise these poor savages, they were often cannibals. But their lives were unhappy; occasionally indeed one comes across records of whole tribes committing mass suicide, feeling that the Land of the Dead, where they would be together with their ancestors, would be preferable to the land of the merciless Encomiendas of the Indies. Fortunately for our peace of mind they left no representations of their oppressors.

It was the virtual depopulation of the West Indies which opened the first trade in slaves on a truly commercial scale. To start with, the Spanish, Portuguese and English merchants brought only an occasional cargo of coloured people from West Africa and Angola. To these captives it was not so terrible a change of fate, as most of them were captives taken in the wars between West African kingdoms who were destined to a life of toil and enforced subjection in any case. In the first century of the slave trade the

market for slave labour was not then sufficient for African chiefs to be incited to go raiding for human booty to sell to the Arab or European traders. These first slaves in the West Indies were the victims of the political wars of the period.

The Portuguese in their progress round Africa made many strange discoveries. In West Africa they found civilisations with which they treated on equal terms. These kingdoms were mostly involved in fluctuating wars, so that it was all rather like the Europe of the period (plate 7). In Africa, however, natural boundaries were not so clearly defined, and the outlines of empires and kingdoms changed more frequently. In fact, the West African states could more accurately be compared with the kingdoms of early medieval Europe. The kings were autocrats, but they surrounded themselves with highly organised courts: there were hierarchical councils, as well as organised churches of a type unknown to the Europeans. For the Portuguese it was a startling contact with the heathendom of pre-Christian times. The kings wore magnificent robes, while their officials all had costumes and insignia which marked their rank. Instead of stone buildings there were fine structures of wood, carved and painted, and sometimes ornamented with metal reliefs. Their technology was almost as advanced as that of Europe, though steel and hard stoneware could not be made because furnaces were not well enough developed. Writing was not normally necessary. There were court officials who were trained to recite history and to keep the accounts of the chancelleries by means of tallies.

In those days the kingdom of Benin proved to be an important trading post (plates 4, 5). There was not so much gold or ivory as in other parts of the coast, but the Bini traded very profitably in spices. An English trader of the early sixteenth century (when Portugal was temporarily under Spanish rule and so in eclipse in Africa) found that a ship loaded with red pepper would make a profit even though it took half a year to make the voyage and half of the crew died from yellow fever. The Bini have left us many eloquent works of art depicting their European visitors of the sixteenth

III A traditional art of Inca Peru adapted for use in the new multi-racial society. The Spanish trumpeter is shown marching between an African drummer and an American Indian official. Wooden beaker *(kero)* decorated with coloured mastic; Peruvian work of the Spanish Colonial period, *c.* 1650. British Museum, London, acquired 1950 (Am. 22.1)

18

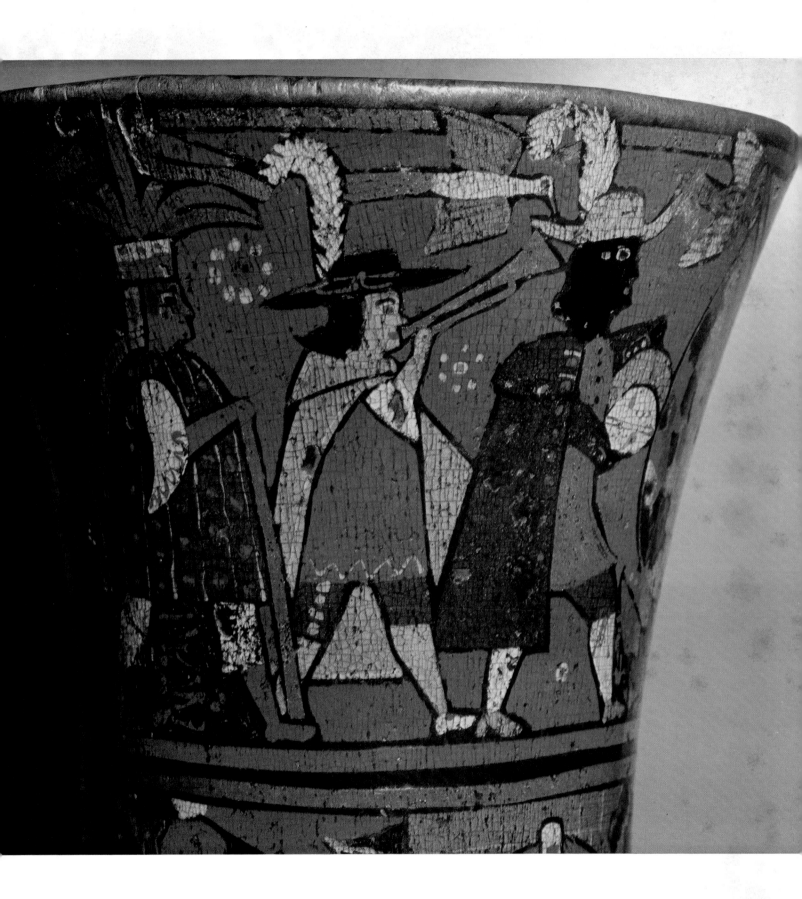

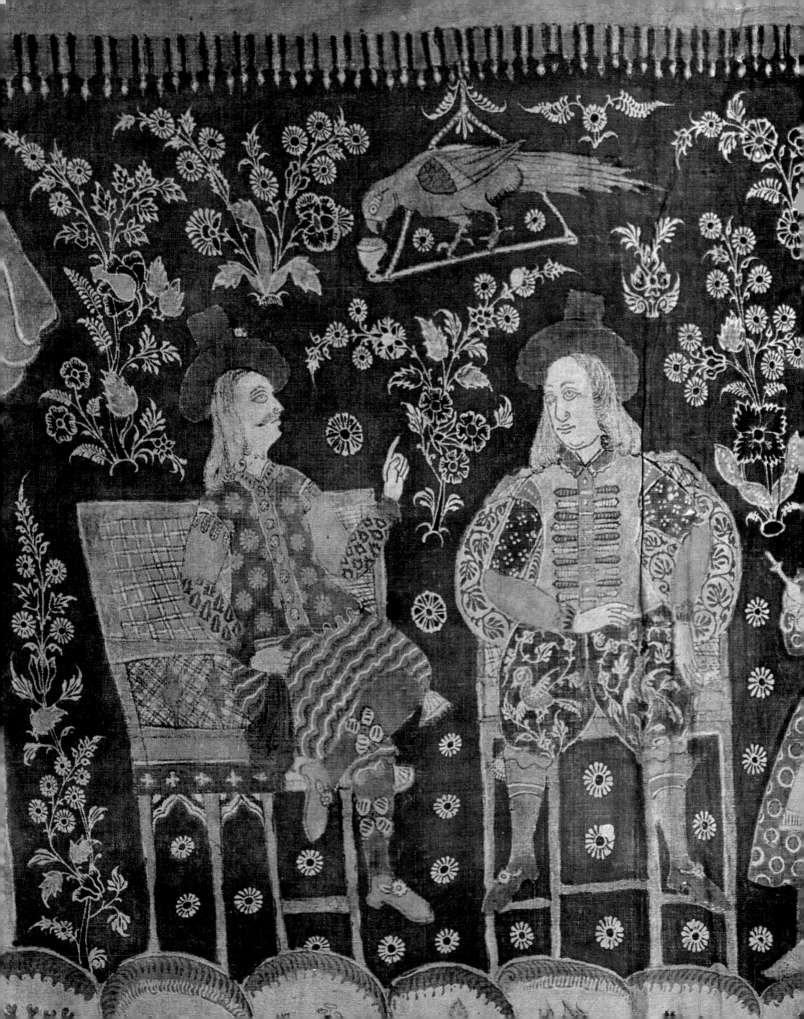

century (plates 4, 5, 6). These works, in ivory and bronze, were made in the local style and in conception and technique owe nothing to the white man.

Portuguese voyagers were accompanied by missionaries as soon as the first reports of the new land were received at home. This period was one of deep religious faith in Europe. The fall of the last of the Moorish kingdoms had demonstrated that western Christendom was a powerful religion; the atrocities of the Inquisition raged because it was felt necessary to extirpate the last remnants of heresy. Thus people tended to be fanatically Christian, in a way which seemed to bear little relation to the religion of humility and love practised by such rare persons as Saint Francis of Assisi (plate 67). It was an attitude which was accepted mostly without reflection. The sailor who killed a heathen savage remained untroubled in his conscience, reflecting that he had just rid the world of one more false and accursed soul. There was little compassion about it. In fact some of the worst excesses in the West Indies were explained by the settlers on the ground that the native peoples had no souls at all, but were merely brute beasts in human form. True, the Pope soon denounced such a shocking belief, but the exploiters still invoked it from time to time.

The first Portuguese missionaries to Benin were not very successful. The king accepted them as very imposing emissaries from his royal brother the king of Portugal, and seeing that they practised strange ceremonies and dressed in magnificent robes, decided to make use of them. He allowed them to accompany him on his campaigns to extend the boundaries of his domains. It did not occur to him that the strangers would expect his people to accept their faith. His idea was to let it be known that as he was the earthly representative of Olokun the Sea God, so he controlled the magicians who came up in the big boats from the far horizons of the ocean. It was a brilliant piece of ideological warfare. However the priests were not so happy, and managed to convey back to Portugal an appeal for help. The second Portuguese embassy to Benin brought some extremely high powered diplomats, who managed to make it clear to the king that he

IV The Europeans, in this case two Dutch merchants, discuss their business. To the Indian artist their clothes and their posture when seated seemed equally outlandish. Meanwhile the tame parrot is unconcerned. Painted cotton cloth from the Coromandel Coast of India. Second half of the 17th century (see also 19, 20). Musée des Arts Décoratifs, Paris (No. 12132)

would not have the privilege of the presence of the religious in his lands much longer, that the mission would be withdrawn unless they were allowed to make converts. The king simply exercised his royal prerogative by ordering his third son and one in three of his nobles to become Christians. This resulted in the appearance of a number of bronze crucifixes at the street corners in Benin City, and some memorial bronze figures of great chiefs wearing crosses on their breasts.

In all these early contacts between the white man and other races there was a general sense of equality. It was just that the Europeans simply did not understand cultures other than their own and so tried to impose their own social systems on the native peoples of other lands. As in the West Indies, the result was destructive. Yet we find neolithic caciques being described as kings, presumed to have control over their subjects on strictly European traditional lines. It might have been a debatable point whether the heathen were to be treated with mercy or tolerance, but it never entered the thoughts of educated people that racial differences of skin colour and hair type had any particular significance. It was all strictly on a religious basis. The case of the conquest of the Americas is significant in this context. The Spanish were sure that their victories were achieved through the help of angelic protection against the devilish wiles of the heathen deities. They did not see the struggle as one of an iron-age civilisation against a chalcolithic culture. Theirs was a holy war against the forces of the devil. The gods of the heathen were the spirits released from hell for a period of time until the coming of militant Christianity drove them back to their place of torment. But no sooner was victory achieved and the native peoples brought into the Christian fold than there were intermarriages on equal terms. Thus, the descendants of the Incas were also by descent Spanish grandees and the daughters of Montezuma were mothers of Spanish-Mexican nobility. It was only after a series of terrible epidemics, and the consequent decimation of the labour force to cultivate and mine the wealth of the land, that the mass of the surviving native people were reduced to an unhappy peonage. Their new owners were, however, the descendants equally of Spanish and American-Indian nobility (plate III). The differentiation, although it was given a racial label, was really a social one. These first stages of contact, although they involved terrible catastrophes, were at least more rational and humane than what was to follow.

Drawing from the book of Huaman Poma de Ayala, who is here shown with his Inca mother and uncle being instructed in the Christian faith by his elder brother

1520, the year which saw the death of Montezuma, the Lord of the Aztecs, was also the year of the death of Magellan, the Portuguese navigator who rounded Cape Horn and opened the dangerous western sea road to the Spice Islands. This was only twenty-four years after Vasco da Gama, having completed the projects originally designed by Prince Henry the Navigator, circumnavigated Africa and found the road to India (plate I).

Ever since the dolphin ships of the Keftiu had left Crete and sailed through the western Pillars of Hercules it had been possible, given the incentive, for man to circumnavigate the globe and make almost endless discoveries. However, apart from occasional transatlantic drift voyages, one or two circumnavigations of Africa by the Phoenicians, and the Viking adventures in Vinland, there had been practically no contact between Europe and the rest of the world, except by land caravan through Asia to India and China, during the more than two millennia in which the possibility existed. Then, in the space of the sixty years after the death of Henry the Navigator, from the first contact with the dark-skinned people in Sierra Leone, European ships had encircled the earth. One reason for this vast exploration was undoubtedly the desire to cut off from the rear the advance of the Turkish power; but even stronger was the need to increase trade.

Of Ormuzd and of Ind

The sixteenth century was a period in which the European ships carried more merchants than settlers. Even in North America there were only temporary settlements at places on the east coast. It seems that the Spanish-American empire was to be understood as a territorial expansion of Spain itself following a war of conquest. A certain amount of exploration was undertaken in the hopes of finding other such empires to conquer, but with no result. However, companies of merchant adventurers developed. Usually they were very strictly controlled by royal licence, and they were both encouraged and exploited by the monarchs, who saw in the merchants a means of increasing their power and wealth at little expense to themselves. The primitive Indians of California made friendly contacts with Sir Francis Drake when he proclaimed their land to be New Albion, and part of the domains of Elizabeth, Queen of England; but there was little gained on either side. On the other hand, much more prosaic companies were formed for trade with the East and West Indies or with India. Mostly these enterprises were organised by maritime nations, led by the Dutch, Swedes, and French, as well as the English. Portugal, by the treaty of Tordesillas, had acquired imperial rights over vast stretches of the Amazonian forest, but she was already in a privileged position in the trade with the Indies because of her early and successful contacts with India at Goa, and with the Spice Islands, particularly with Timor and the Moluccas.

The really successful traders were those with trading ports in the highly civilised kingdoms of the East. Almost equally successful were the peoples trading with West Africa, but these had less scope since the coasts of Africa tended to be unhealthy and the seaports were not near the real centres of power and trade. These were inland cities facing towards the Sahara trade routes rather than the tropical shallow seas off the Bight of Benin.

The extension of world trade was now seen to be the correct goal for the kingdoms of Europe. There was no longer a drive to seek out the mysterious kingdom of Prester John or to drive back the Mohammedan powers. Byzantium was gone and

the confrontation with the Turkish empire was a regional one across south-eastern Europe. Here the struggle, which concerned Austria and Poland most deeply, was to last for two centuries. It had bitter religious undertones but developed into a struggle between imperial powers and was in many ways a battle for a social system which characterised European life. This vital struggle was isolated from world exploration. Commercial missions from the West continued to contact Turkey, obtaining valuable trading concessions. Others went to Muscovy and established rich commercial exchanges with the expanding Russian power.

All overland routes were becoming expensive in comparison with water-borne transport. Larger ships were being built which could travel farther and carry cargoes measured by the hundred tons. As yet, there was no method of preserving cargoes for long voyages and only non-perishable cargoes were worth transporting. Food for the crews was little changed from Viking days, when hard bread rings, cheeses, and a few live animals were carried on the transatlantic voyages. There was no provision against disease, and fresh food could only be obtained by making calls at fixed trading posts, which soon sprang up around the world, and which, as a natural precaution against trouble or war, soon developed into forts. These forts were usually garrisoned by white soldiers, with the local people attached in many ways as merchants and servants. The essential condition for the establishment of a trading port was that it must be profitable to both sides. Although there were occasional fights the absence of forced trading concessions marked the general development. In the Americas, especially in the West Indies, conditions were different. Private traders and pirates all attempted to invade the jealously protected markets of the Spanish colonies, and kept up a practically continuous state of war. In Mexican paintings we sometimes find the captured Lutheran seamen dressed in San Benitos and carrying candles, showing that the Inquisition was about to deal with them—usually murderously.

In India the position was quite different. The Europeans could not hope to make any deep impression on the Great Mogul who was ruling most of India from his capital at Delhi. The conquest of India by the princes of the Barlas Turk dynasty was consolidated by the first Mogul emperor Babar in 1526. It was of only minor consequence to the emperor that Velha Goa had been captured by the Portuguese in 1510,

and was sometimes at war with the rulers of nearby Bijapur. Its importance for trading contacts was, however, much greater (plates 19, 20). Naturally other European traders, French, Dutch and English, visited India and arranged to set up similar small trading stations, but one can hardly say that they had much effect on Indian culture in the first century of their presence there. The Indians saw the Europeans as a race of useful traders, but found no reason to exchange any of their traditions for those of the visitors.

To the visitors still within the intellectual framework of the European feudal tradition, the delegation of local power to kings and princes in the Mogul empire seemed familiar. They were astonished at the arts and the immense riches of the East, but the trade they offered in European goods, and particularly in arms and coin, was acceptable. At last the people of Europe became acquainted with the fine cotton goods, silk, ivory, sandalwood and many beautiful things not seen for centuries past. To the artists of India the white men were interesting visitors, and the court painters occasionally recorded the appearance of these merchants from distant lands as they saw them—strange people in strange clothes and with a formal stiffness (plates I, 1, 2, 3, 20, 21, 24).

Further east the great explorers were Spanish and Portuguese, coming from opposite directions. The Spanish-American colonies sent armadas of fine ships to trade with the Spice Islands, and occasionally as far as India and China. In particular they based themselves on the Philippine Islands. The Portuguese settled in trading ports on the western points of the Indonesian archipelago, but tended to make further advances towards China and Japan. The reason for their greater adventurousness in this field was simply commercial need.

For some time Portugal had been ruled by Spanish sovereigns, but with its restored independence something had to be done to counterbalance the immense treasure which was pouring into the Habsburg coffers from Mexico and Peru. The internal economy of the smaller European nations was no longer sufficient to ensure their positions of power; the discrepancies in wealth were too great, and wealth in those times was the means by which kings held their realms in the face of attempts to control them. The Portuguese case was not unlike that of the English at that time. Similarly the French were feeling the need for competitive exploration and trade. But all these

26

1—3 The Portuguese in Ceylon. The artist has probably worked from Portuguese drawings or carvings, since he has followed traditional patterns of design in European art. The fighting men are shown wearing quilted armour rather than the heavy steel plate still worn in Europe. The whole group of scenes suggests illustrations to some romance of chivalry. In 1) the contestants joust with short javelins instead of lances. In 2) a mounted nobleman accompanied by arquebusier and pikeman signals from his richly caparisoned horse. In 3) we are presented with a quarrel which is about to turn into a duel, to the horror of the gentleman looking on (see also colour plate I). Panels from an ivory casket of Ceylonese work, *c.* 1540. Schatzkammer of the Residenz in Munich (No. 1242)

4 A leopard hunt in the long grass of a forest clearing in southern Nigeria. The Portuguese warriors, all helmeted, carry arquebuses for shooting the leopards while their assistants carry daggers to finish off the animals which they then sieze by the hind legs. Cast brass plaque of the 17th century, from the palace of the Oba of Benin. Staatliches Museum für Völkerkunde, Berlin-Dahlem

5 The Christian Warrior. A Portuguese nobleman finely dressed in the high fashion of his day. The African artist has noticed the strange bearded face and emphasised its ferocity by the gesture of the hand grasping the sword. This is one of a group of figures forming the base of an ivory standing salt for use on a dining table. Benin, Nigeria, 17th century, British Museum, London (1878. 11—1.48)

6 Land observed from the crow's nest on the topmast. A Portuguese sailor looks towards the coast of Africa while his ship rides the rollers with her sea-anchors out. The reduction of the form to the simplest possible statement shows a long acquaintance with artistic expression. Benin work, Nigeria, 17th century. (Same salt as plate 5). British Museum, London (1878. 11—1.48)

7 The Oba of Benin wields his broad ceremonial sword *(ebere)* as he marches to a celebration, followed by mounted Portuguese soldiers. A section from a carved ivory armlet, 17th century, from Benin, Nigeria. British Museum, London (1949. Af. 46.179)

8 Ease and exhaustion in the tropical forests. The European traveller in Angola is carried by his bearers in a mattress hammock. He is enduring the steamy heat which hardly causes any discomfort to his sturdy bearers. BaKongo carving from Angola, late 19th century. Rijksmuseum voor Land-en Volkenkunde, Rotterdam (28566)

9 A military escort for the European Officer. This rail from a chieftain's chair shows a white officer with his Congolese soldiers seated in a carrying-chair. The rifles of the soldiers are combined with a rail which suggests the idea of the carrying poles without actually stating it as a continuous rod. BaDjokwe work of the early 20th century. Southern Kasai-territory. Musée Royal de l'Afrique Centrale, Tervuren (No. 40078)

10 A chieftain's chair showing the Belgian magistrate trying a case in court, and the prisoner being led away with a rope round his neck. There seems to be some hint here that the chief was also a dispenser of justice among his own people. BaDjokwe work of the early 20th century. Southern Kasai-territory. Musée Royal de l'Afrique Centrale, Tervuren (No. 35793)

11 Coming ashore on a formal visit. The Dutch naval officers are paying a courtesy visit to a town in Angola, and manage to maintain some dignity as the BaKongo porters take them on their shoulders to bring them ashore. This small ivory carving is BaKongo work from Angola, mid 19th century. Rijksmuseum voor Land- en Volkenkunde, Rotterdam (28629)

12 The beloved teacher, a carving representing Mr. Kenneth Robertson, an English school teacher who had been thoroughly accepted by his pupils and their parents. The expression of one who knows the value of the knowledge in his book makes this small carving an outstanding work of art. Yoruba people, Nigeria, about 1930. British Museum, London (1966. Af. 4.1)

13 The white man sits thinking. The carver has been somewhat confused by the idea of crossing extended legs, but has made a satisfactory design, so that the European rests with his feet up, but the slight tension of his deep thought is as apparent in his feet as in the hand stroking his beard and the expression of his face. A carved wooden comb from a BaDjokwe group in the southern Congo. Musée Royal de l'Afrique Centrale, Tervuren (No. 28741)

14 The rider encourages his reluctant horse with a riding switch. This pottery figure catches the seat of a good horseman extremely well. The potter has also used European script on his pot in a very satisfactory design with a fine Latin script. Northern Angola, early 20th century. Musée Royal de l'Afrique Centrale, Tervuren (No. 51.12.1. ½)

15 The reader, a study of a European official studying his book, and seated on a throne. Cire-perdue bronze of Javanese work, Mid-19th century. Rijksmuseum voor Volkenkunde, Leiden

16 Tropical fashion in old Java. Two Dutch ladies at their tea table. The table is European in style, but the chairs are of local make possibly of a Chinese pattern. Cire-perdue bronze casting from Java, Mid-19th century. Rijksmuseum voor Volkenkunde, Leiden

17 They too could give pleasure. Ivory carving on a small tusk representing two young European men with a naked Angolan girl. This pleasant little work was collected by John J. Coker in

1848. BaKongo work, Angola. Peabody Museum, Salem (No. E 16924)

18 This group is not really Pygmalion and Galatea, but two separate small ivories. The seaman appears to be a portrait rather well executed and showing a considerable difference from the features usually given to the local Portuguese in Angolan carvings of this period. The lady appears to derive from a ship's figure-head of the time. Western Africa, probably Angola, early 19th century. Peabody Museum, Salem (E 6757 and E 11594)

19 The ships sailed upriver past the woods and wild animals. In the rigging sailors climbed aloft; the Captain stood on deck and the sides of the vessel were full of guns. This is a painted cotton cloth from the Coromandel Coast of India, depicting a Dutch trading vessel; second half of the 17th century. Musée des Arts Décoratifs, Paris (No. 12132)

20 The Rajah sent his servants to escort the chief of the foreign merchants. The artist has carefully observed features, dress and posture and so projected his view of the stranger in detail for the future to see. Painted cotton cloth from the Coromandel Coast of India, second half of the 17th century. Musée des Arts Décoratifs, Paris (No. 12132)

21 A great commercial embassy to the Emperor. This Mogul painting on silk is traditionally known to be a representation of Jan Josua Ketelaer, Ambassador of the Netherlands East India Company travelling to the Great Mogul, Shah Jahandar at Delhi in 1712. Tropenmuseum, Amsterdam (A 9584)

22 The planter is contented as his overseer examines the tea bushes, and the Indian girls carry earth in baskets to the irrigation-works. Indian painting of the late 18th century. Victoria and Albert Museum, London (I. S. 75–1954–2–)

23 An officer of the East-India Company takes his ease with Indian tobacco smoked in his hookah. He has no need for the protection of the dress sword beside him, because he gains their confidence by caring for the health of the local princes. Indian painting by Dip Chand, late 18th century. Victoria and Albert Museum, London (J. M. 33–1912)

24 The Dutch trader wears interesting clothing which the artist delights in rendering. By now he was probably used to the idea of the crude Europeans smoking long stemmed pipes instead of the hookah. A lacquer box, Deccan, India, c. 1660. Victoria and Albert Museum, London (851–1889)

25 The English planter kills the tiger without fear. The artist seems to have been confused about the mechanism of guns, unless this is a special pattern for hunting tigers. The planter has a fine tail coat made of Indian cloth, and his hat appears to be a lightweight cane construction. Indian painting, early 19th century. Victoria and Albert Museum, London (I. S. 209–1950)

26 Imperial French soldier in a northern land. Here Hokusai has depicted a Russian soldier cleaning his musket. In the background the mountains and a Russian church point to a Russian landscape (Napoleon I. in Russia?). Note the significance of the Phoenix flying across the sky. Japanese colour print from a woodblock by Hokusai, early 19th century. C. T. Loo Collection, Paris

27 The ship's gunner has become a mercenary in the service of an Indian rajah. Many such experts found employment in Indian domestic wars in the 18th and 19th century. One notes the exact care which the gun layer displays at his work. Indian miniature. Pakari-style, late 18th century. Rijksmuseum voor Volkenkunde, Leiden

28 Foreign sailors (possibly Portuguese) enjoying the mountain scenery from rocky meadows level with the clouds. The artist has filled in the background of his work with fortunate symbols of plum blossom and birds. Said to be Chinese, but more probably Japanese late 17th century. The panel is carved in soapstone. Private collection, Prague

29 The new steamship, still partly relying on sail, sends out its landing crew. The Midshipman calls out through his speaking-trumpet, the marines sit on guard, and the boat's crew struggle with the water. The problem has been the flags which are mixed Dutch-English-Russian, but the whole scene is a realistic view of the fact of a steamship. Japanese colour print from a woodblock, early 19th century. British Museum, London (1931. 7–14.324)

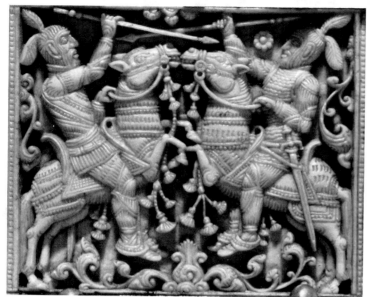
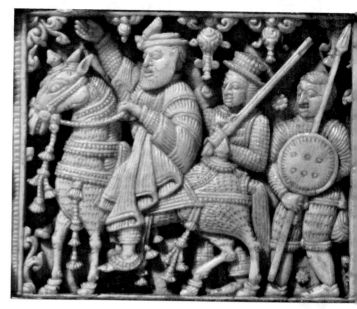

1, 2

3

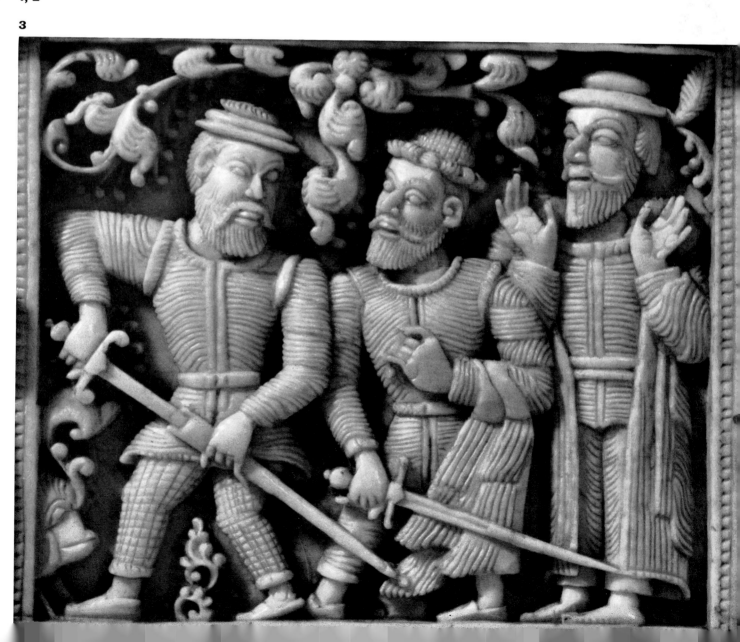

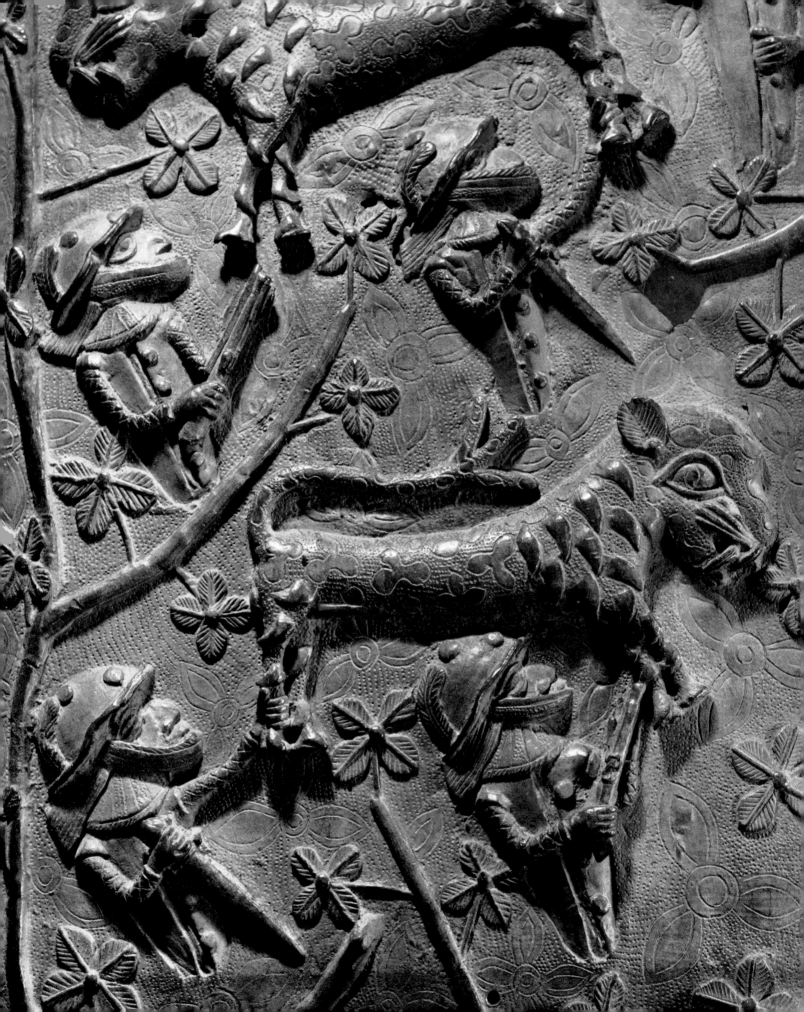

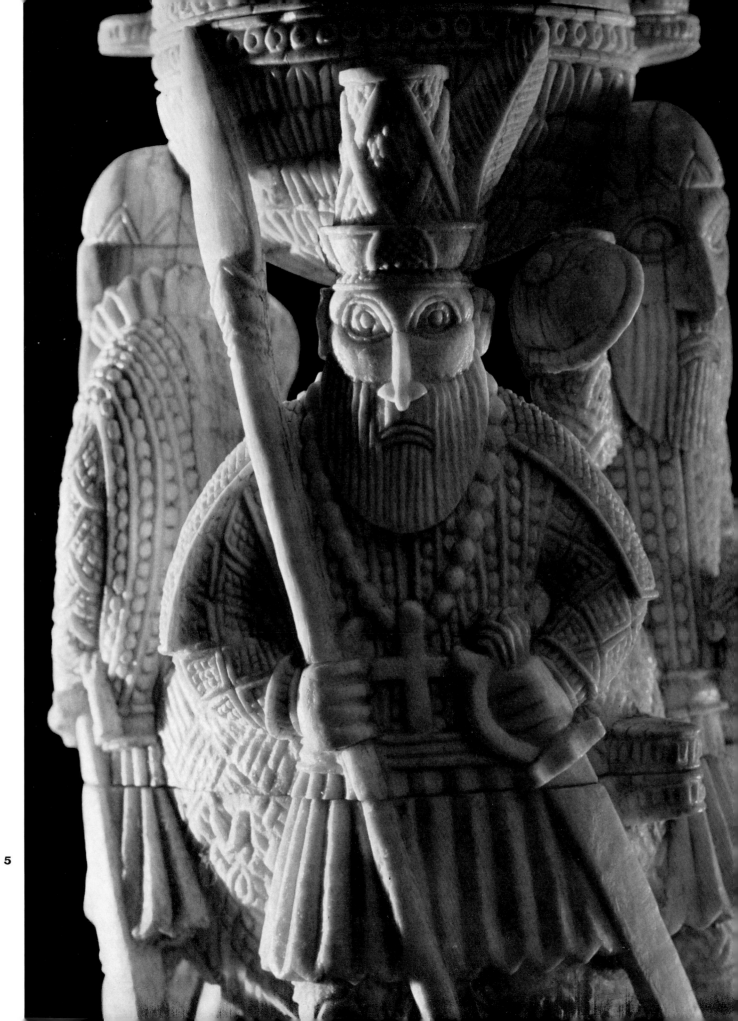

5

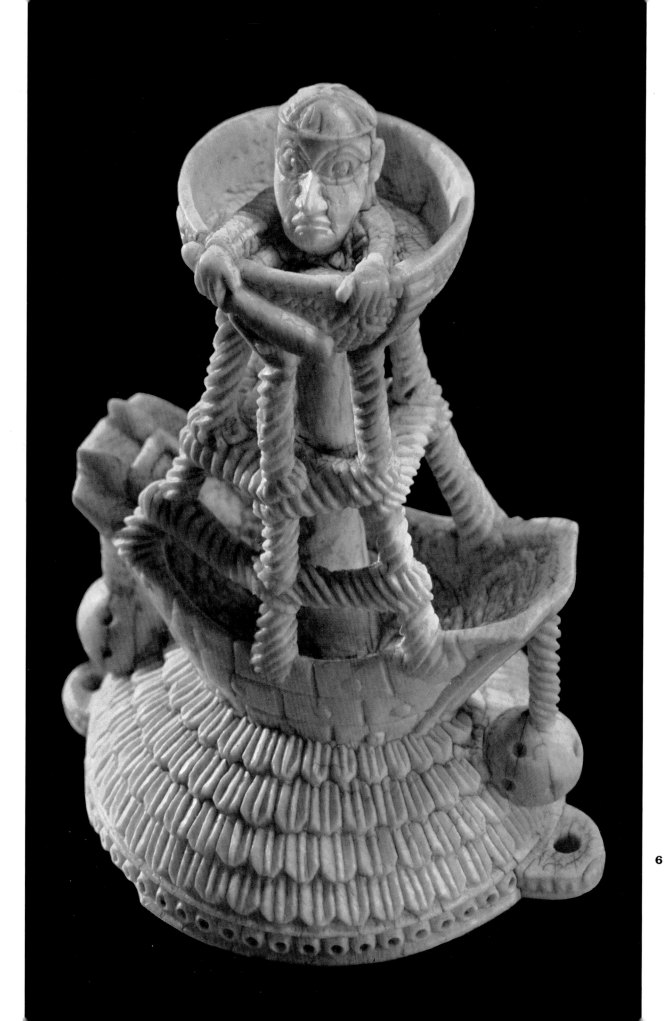

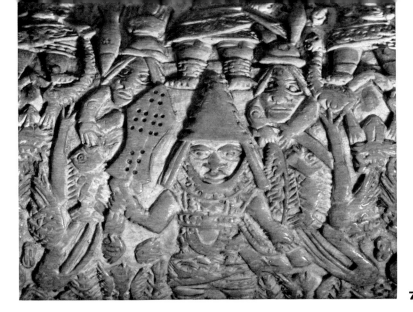

7

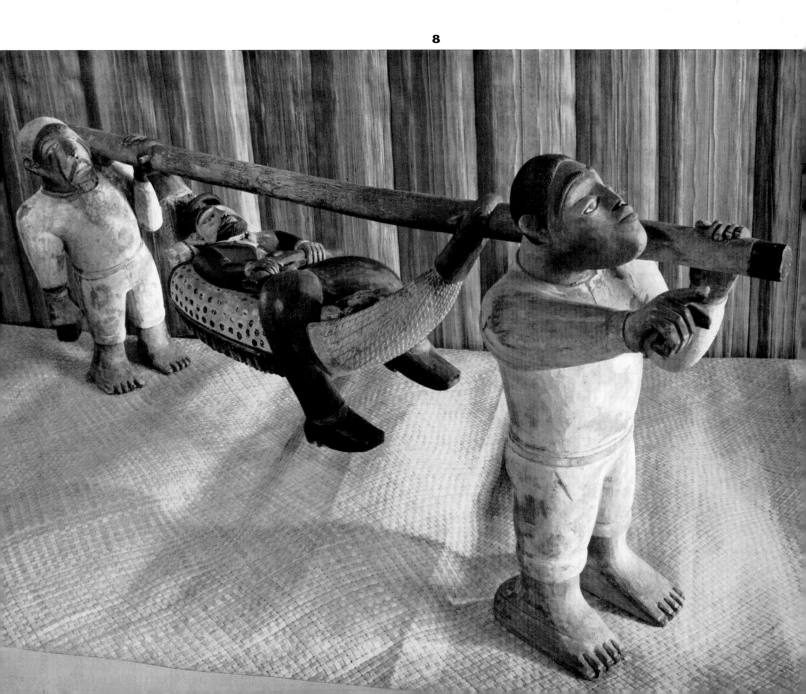

8

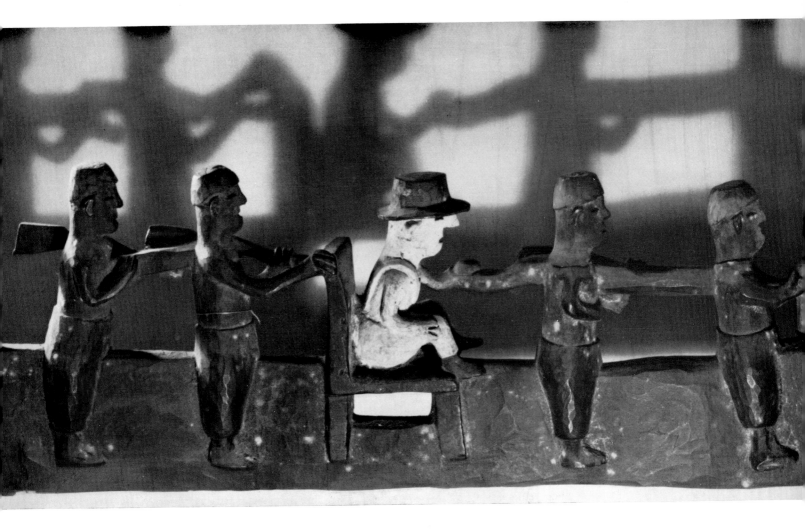

9

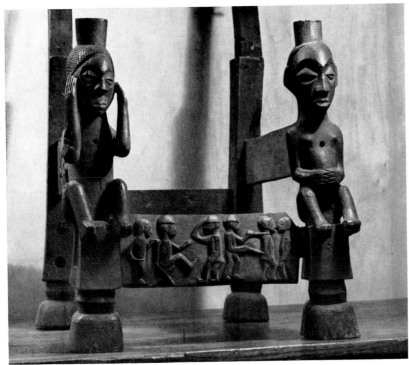

10

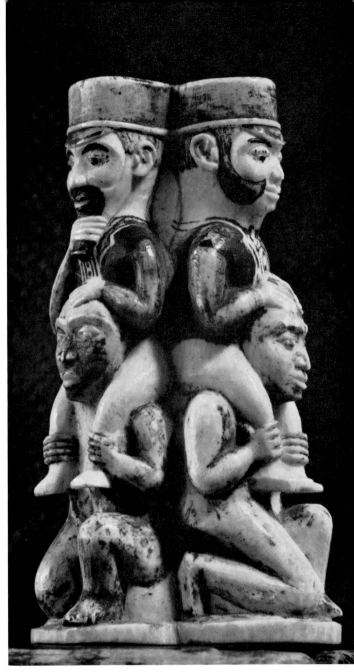

11

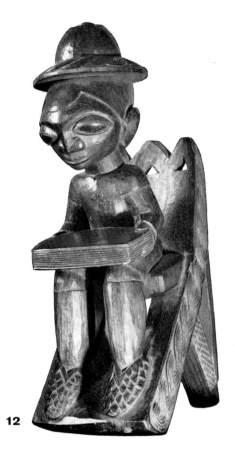

12

13

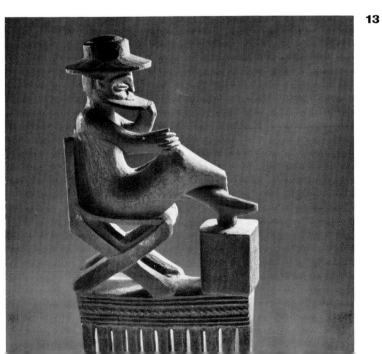

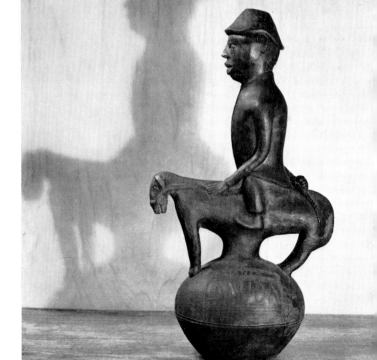

14

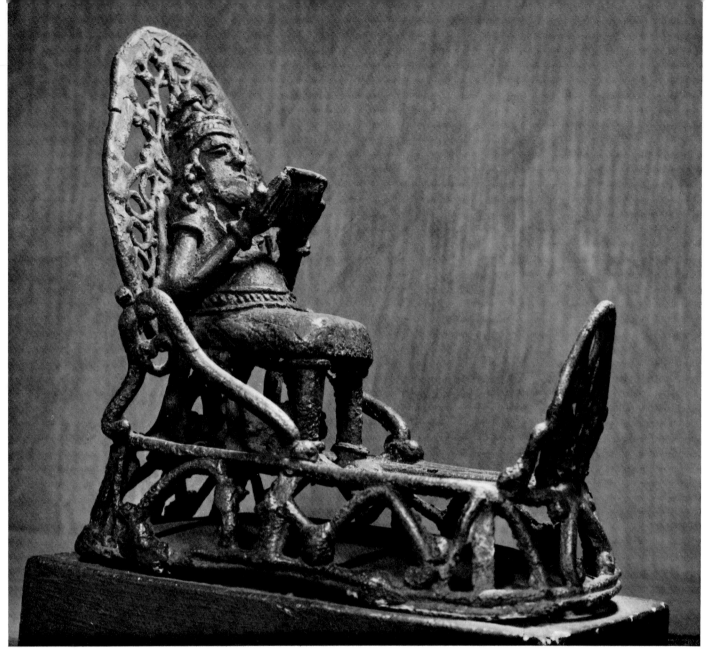

15

16

18

17

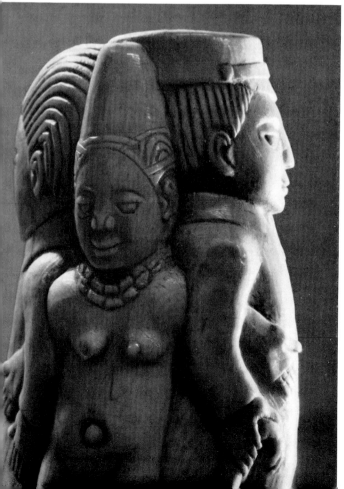

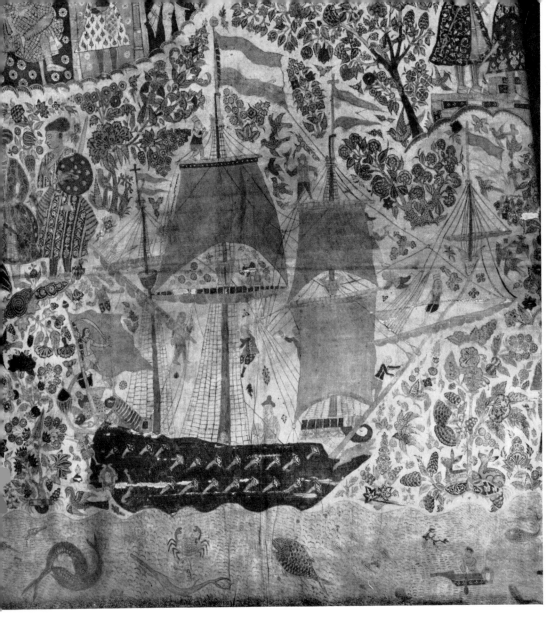

19

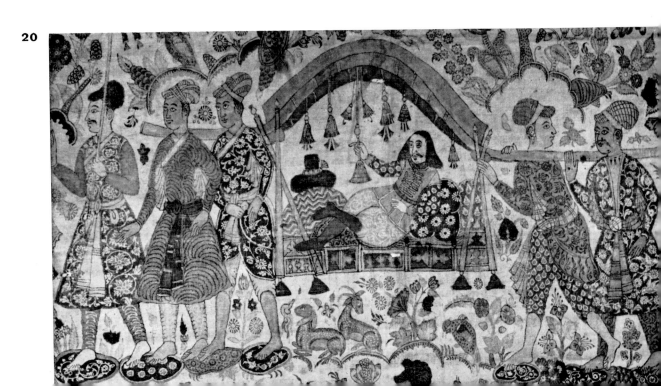

20

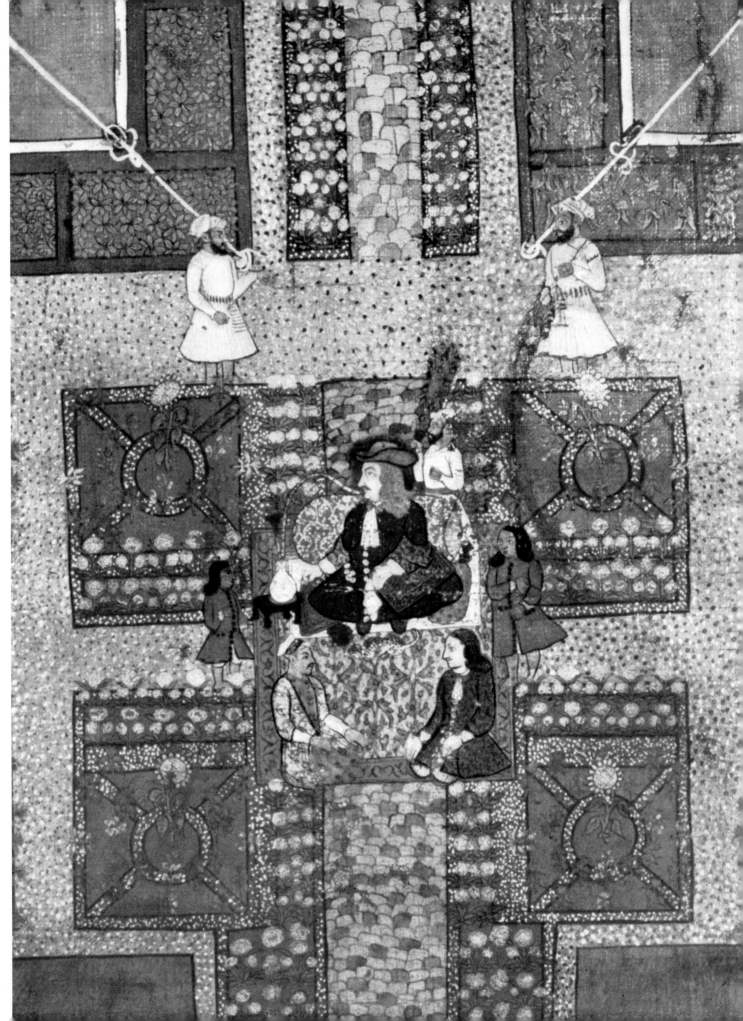

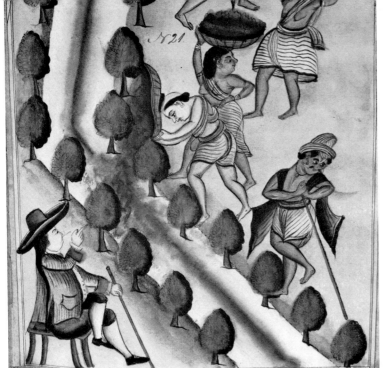

22

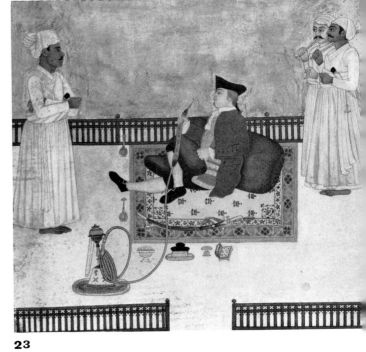

23

24

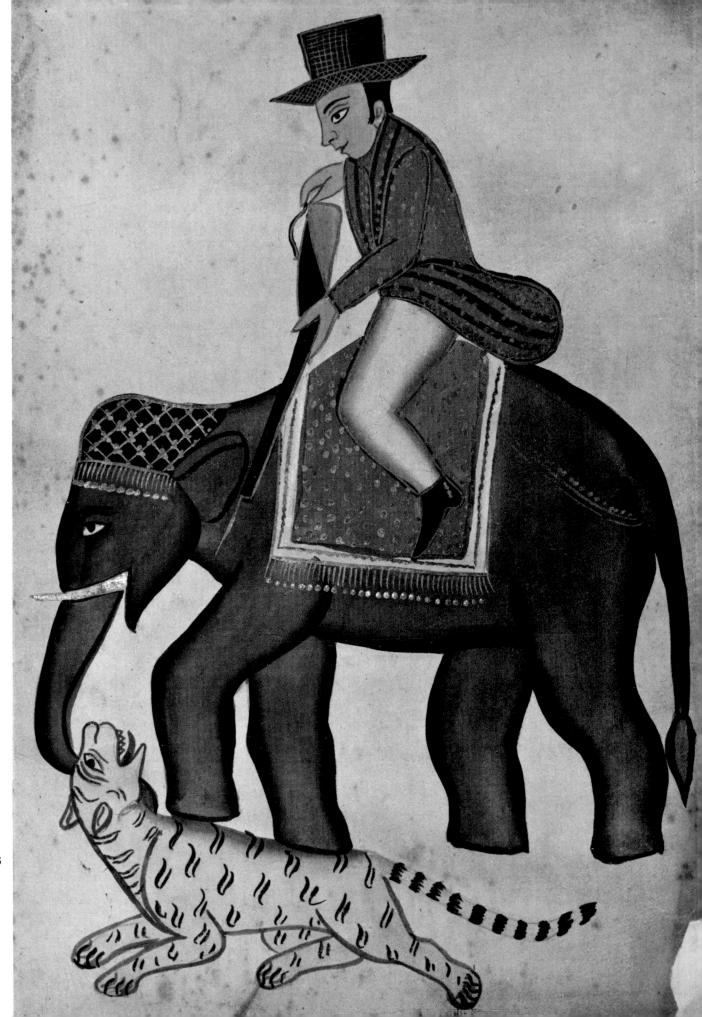

25

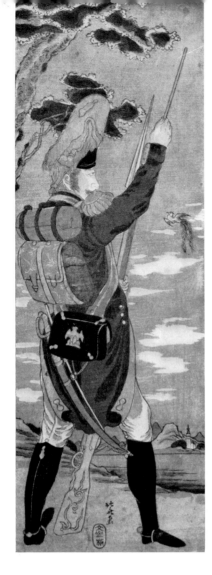

26

28

27

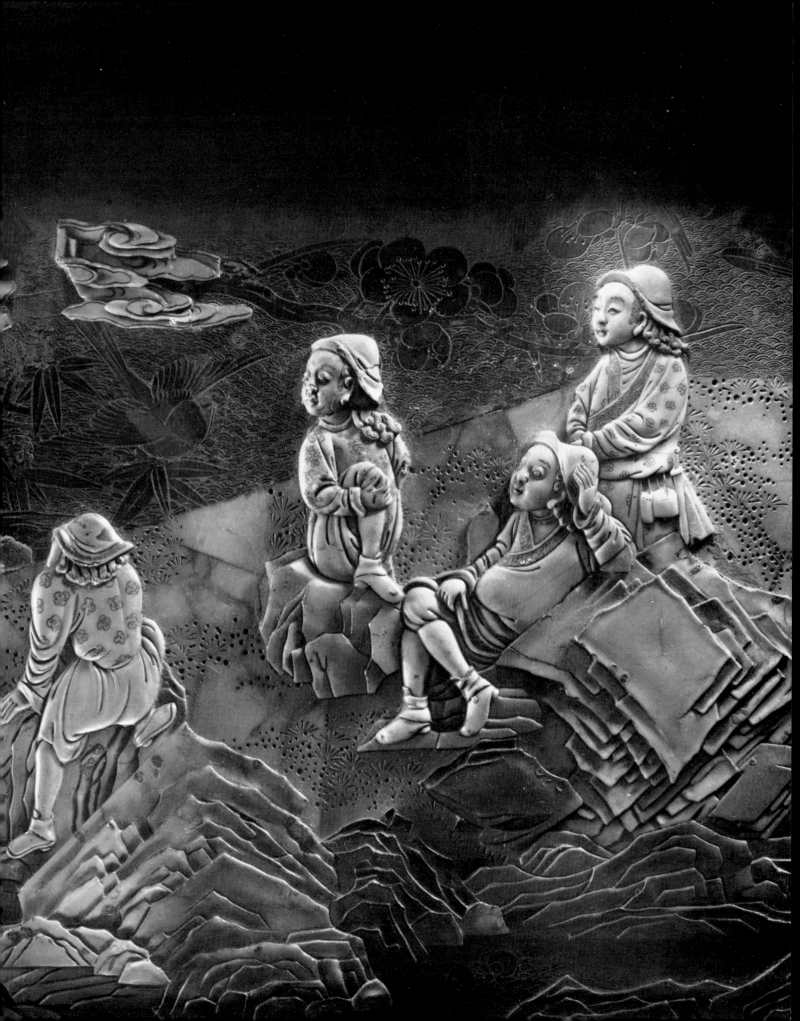

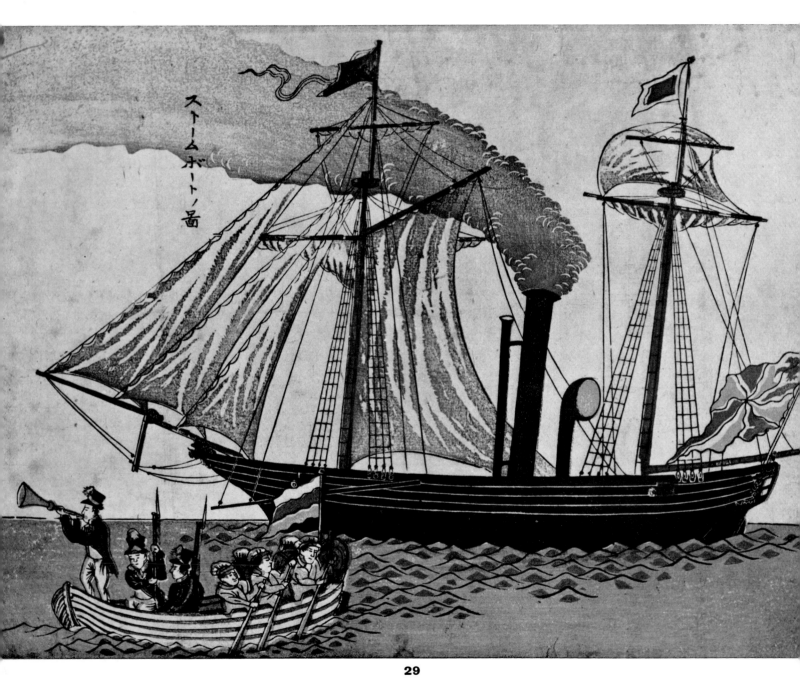

スチームボートノ畫

29

other nations, though seen in the Far East as useful strangers whose competition kept trade prices reasonably buoyant, had rather less impact than the Portuguese.

To the native artists of the East the foreigners brought another interesting experience, the missionary (plates 44, 61, 77). Neither the Spaniards nor the Portuguese were, in principle, materialists. They felt the need to proselytise among the people with whom they traded, introducing Christian concepts and ceremonies to them as the symbolic statement of an ultimate truth. Priests often accompanied the traders, and the governments encouraged their work. This was often in strange contrast to the harsh and repressive treatment accorded to the native people under the control of the northern European colonists. Even so, the faith behind this missionary activity was sincere and passionate. In particular, the Jesuits St Ignatius Loyola and St Francis Xavier left enduring memories in these Asian lands. The missionaries were usually people who did not think of drawing any distinction between different groups of humans for biological reasons. True, they respected national states and the contemporary social systems. They accepted the fact of slavery as they accepted class hierarchy, not only among the newly discovered nations but also in their home lands. Their general attitude towards this human problem was that of the earliest Christians in the Roman empire, to enjoin the upper classes to care for and protect their servants, as their lesser brethren. Of course social and commercial considerations often overwhelmed the missionaries' aims; but there was a conscious attempt to follow the principles of their religion.

The European situation bedevilled relationships in the trading posts. Reformation, Counter-Reformation, kings who apostatised, and the trials of heretics were symptoms of a spiritual upheaval in Europe which broadened into political conflict in the outside world. The heathen and the heretic became confused in many minds. One cannot comprehend the evils perpetrated in these tropical settlements without remembering that far worse excesses were taking place in Europe. Artistically this brought examples of highly emotional painting and sculpture before the local converts. As in more recent times, the local artists who came to accept the religion brought by the European missionaries also accepted European art styles, often completely abandoning, in a sadly facile way, their old ideas. Occasionally, the quality and form of this Christian art in the Far East became so nearly European that it takes an expert eye to make the distinction.

In India, China and Japan the traditional cultures were sufficiently strong to resist European secular art, and we find the traders and soldiers depicted through native artistic traditions with great skill and beauty (plates I, IV, 24, VII, 43, 52). But in the smaller cultures, as in the Indonesian islands, there was even a conscious attempt to imitate the outward forms of European dress and accoutrements. Many a style of dress and armour in Indonesia has its ancestry in the visitors and settlers from Europe and Latin America. Somewhat similarly, African kings and the more important chiefs accepted presents from the traders and some established courts on the European model. The penetration of ideas into African art did not last, nor was it as important as in Asia.

Towards the end of the sixteenth century there were considerable changes within Asia. In India the Mogul emperors had reached the zenith of their power and prestige under the cultured and intelligent Akbar (plate VII), and his successor Aurungzebe managed to maintain the efficiency and organisation of the state. In China the Ming emperors had declined in power, and their intense nationalism had consequently weakened. Much foolishness and oppression was ended in the seventeenth century by the establishment of the Manchu dynasty. By this period European traders were taking an active part in political affairs, a part which was dictated by business interest (plates 28, 37). They tended to support the old authorities (or, in the case of China an internal political faction which bitterly opposed the Manchu), protecting the privileges they had already won and preferring to deal with people whose ways were familiar to them. There was at that time no intention of interfering in the internal affairs of China; such intervention was of little importance for the next two centuries, until the disgraceful episode of the opium wars. In Japan political changes were even more catastrophic for European interests (plates VI, 35, 43). The weak emperors, whose luxurious and lax courts were surrounded by warring factions of daimyo, lost their political and military influence to the new regime of the Shoguns. At first the great Shogun Hideyoshi had no objection to the Europeans trading in Japan, but later he decided that Japan must throw out all foreign intrigue, and following the strictest path of Zen Buddhist ideals he set out to purify Japan. The work ranged from the extermination of foreign beliefs to the introduction of the refined and elegant tea ceremony. The Europeans were cast out or killed. The Jesuits in particular suffered cruel martyrdoms, together with

hundreds of their Christian Japanese converts. After that the Europeans became objects of derision, though still useful as traders, and the Japanese Christians were forced into becoming an 'underground' movement, in which form they survived with a strange ceremonial life of their own, becoming an open church again only after the Japanese emperor had signed agreements with the western nations in the last quarter of the nineteenth century. As fate would have it, this indigenous church was based principally in the provincial town of Hiroshima, until other Christians in the pursuance of their official duties obliterated it in 1945—a strange and unholy retaliation for the torments once inflicted by the executioners sent by Hideyoshi.

Throughout the whole of this early period the European trading organisations combatted each other on a nationalist basis, and the local people had many an opportunity to see the military equipment of the white man. Occasionally they were themselves subjected to piratical raids, and forced settlements were made, but this was not the usual pattern of events. Normally the local ruler controlled and directed trade, and on the whole acceptable and fair exchanges were made in open markets.

The greatest change in the trading contacts of the Europeans came with the liberation of the Dutch from the Spanish Habsburg empire. This newly liberated nation was faced with the problem of building a new life through international commerce, and inevitably this was to bring them into conflict with English and French interests as well as those of Spain and Portugal; but with immense inner strength they set out on their career in world trade (plate 31). The whole business organisation of the new state was aimed at bringing the profitable products of the tropics to the markets of Europe, and in particular to the more or less landlocked German states accessible to the Dutch through the Rhine and Schelde. There were few reasons for seeking territorial aggrandisement overseas, but the establishment of trading posts was vital. It was almost by chance that the confrontation between Dutch and Portuguese traders eventually led to the Dutch political control of Indonesia. Apart from this the settlements were few and small.

New Amsterdam and a few West Indian strongholds became the American centres. Their trading posts spread to West Africa, and on to the foundation of a supply depot at Kaapstad. In the past, the Portuguese and other nations had found no trading

possibilities in southern Africa. What is now Cape Province was at that time inhabited by palaeolithic hunters, the Hottentots and Bushmen. But the Dutch East India Company made use of the Cape for the establishment of storehouses and small farms, so that the crews could rest and the ships be repaired and stocked up with fresh supplies of meat and vegetables. We know of no Bushman paintings of these strangers, though a few rock engravings, probably made by Strandloopers, show shapes of ships. It was only later that the Bushmen artists saw enough of the Afrikaners to depict the great ox waggons and the strange red men who commanded them. But Cape Town was at first a new kind of commercial settlement, a transit base on the sea roads of half the world.

The advent of the Dutch in Asia was more purely commercial than anything which had gone before (plates 21, 28, VI, 33, 35, 41, 48, 49, 50, 51). The merchants were competing against other Europeans. They felt the need to deal on a strict and sound commercial basis, and were willing to accept conditions laid down by native rulers in order to achieve their ends. True, competition with the other Europeans was intense, and violence and, often enough, trickery and betrayal were used to defeat their enemies. They aroused fierce antagonism and hatred by such actions, but their trade prospered. Their methods after all were no worse than those indulged in by the British, French and Spanish trading organisations in the Far East; but they were less political and more commercial in purpose.

European contacts with eastern Africa and Persia were comparatively few during the period we are considering. The Arab traders still held commercial control of eastern Africa and the Indian Ocean, though the Portuguese were able to reach the Arab port at Sofala, from there travelling inland to visit the great king, the Monomotapa, who ruled in Zimbabwe, and trading in gold and ivory with the Arabs. Some individual European travellers penetrated the Red Sea and Persian Gulf, but to little effect. The real contact with the Islamic world was still through the Levantine ports, mostly through the ships of Venice. The caravan trade brought to the ports silk and eastern carpets as well as beautiful jewellery, but this trade was on a comparatively small scale and subject to the usual insecurities of bandits on land and piracy at sea. On the whole the Islamic world discouraged contact with Europeans, and so the traders of western

Seventeenth-century print showing the market and warehouses built by Portuguese merchants at Goa

Europe continued in their circumnavigation of southern Africa, for them still the safest and most profitable route to the east.

The most valuable items of trade were spices, the delicate flavours of the East Indian pepper, nutmeg, and mace being more esteemed than the stronger peppers of West Africa. The East African city of Zanzibar was already famous for its trade in aromatic cloves; Arab businessmen there had no great objection to occasionally selling a boatload to the infidels from beyond the further shores of Africa. Textiles were also exchanged in considerable quantities. In a world where both East and West relied on the handloom for the weaving of cloth the market existed on a basis of almost reciprocal exchange. European velvets and lace were of interest to the East, and Chinese silks, Indian muslins (plates IV, 19—22), cottons and fine carpets were all in demand in Europe. Ceramics were also highly esteemed in Europe, especially work from China and Japan. The Ming and early Manchu potters fashioned objets d'art which delighted Europeans and started the charming fashion for Chinoiserie in the mid-seventeenth century. The palaces of Europe of the period, from Hampton Court to Schönbrunn, were decorated with Chinese ceramics. So important, in fact, did the trade become that oriental potters were soon being commissioned to manufacture sets of utensils and dishes of European style, with European scenes depicted on them (plate 37). The production of imitation China wares soon began in Europe, extending in the next century to bone china and then to a European version of porcelain, which, however, never quite attained the perfection of the Chinese product.

With its increasing wealth from trade and the colonial exploitation of the Americas, Europe had set foot on a new path of economic development. The limitations of medieval life were ended. The rivalries between nations were no longer over territorial aggrandisement so much as control of wealth, particularly of the fruits of commercial enterprise. By the end of the seventeenth century the stage was set; the scattered trading posts were soon to develop into powerful empires. European culture had by now progressed to a point where its control of natural forces was more scientific and accomplished than in other parts of the world. Technical abilities were developed, so that European ships and armaments became much more powerful than those of other nations. Yet the peoples of Asia still observed the stranger in their midst.

30 The gentleman and his lady. Once again the detail tells us a lot about the Europeans of the period. Note the length of hair, the way the lady ties on her hat, and the cockade on the gentleman's top hat. It is possible that the lady would use the pipe herself, but she may well be holding the delicate clay tube while her husband uses his telescope. First quarter of the 19th century. Japanese colour print from a woodblock. British Museum, London (1946. 4–1.03)

31 The barbarous Europeans were allowed to trade only from an artificial island, the little Dutch settlement of Deshima with its offices and storehouses. A Netherlands merchant vessel dressed overall approaches. In the distance small Japanese boats sail behind another big ship. Japanese painting on paper, late 18th century. Dutch Private Collection

32 To frighten off dangerous powers by their own representation was the purpose of this painted board. The sea dragon is the danger, but there is a cargo of the white gentleman and his tight-waisted lady, with mirrors beside them. Are they the spirits one sees in the moon? The artist seems to have thought so. A carved wooden board from the Nicobar Islands, late 19th century. Rijksmuseum voor Volkenkunde, Leiden

33 Japanese officials visit the Dutch traders on the island of Deshima. They have brought some elegant geisha with them to entertain their hosts, but the artist notes the coarseness of the Europeans and their pile of saké bottles against the wall. Meanwhile a Javanese servant brings delicacies to the table. Japanese painting on paper, early 19th century. Dutch Private Collection

34 The Customs House at Yokohama, where ships from all the powerful nations came to trade with Japan. The artist has recorded fact and not betrayed any resentment that this building only opened after the country had been forced to open her harbours for trade under a threat of bombardment from an international fleet of which the first ship was commanded by the American Commodore Perry. Japanese ink drawing c. 1880. Rijksmuseum voor Volkenkunde, Leiden

35 The Europeans were strange people and often wore beards. This is an ojime, a metal counterbalance to the inro, a laquered box worn at the belt. The two objects were joined by a silk cord which looped over the belt. Japanese, early 18th century. Rijksmuseum voor Volkenkunde, Leiden

36 The Captain at Shimabara. The Captain is wearing formal dress, but he is spilling his drink because he has been entranced by the singing of the actress who lifts her empty cup in the course of her performance. Here at least there is an indication of the European appreciating the more

elegant arts. Page from 'Residential Rhymes' with a text in English, printed in Tokyo c. 1900. Private collection, Holland

37 A traditional and formal representation of a scene from European history. This represents King Lous XIV and Madame de Montespan accompanied by a greyhound. The Roi Soleil would not have appreciated the picture. From a Chinese plate painted in black, red, green and gold, early 19th century. Östasiatiska Museet, Stockholm

38 A folk-tale becomes a warning against mixed marriages. The inscription tells us that to the amazement of the parents, and of the whole population of the town, a Japanese girl bore a child to a white sailor. The little boy not only had a white skin, but was bearded and excessively hairy, and although newborn could stand and display remarkable strength. Japanese colour print, late 19th century. Dutch Private Collection

39 The wonders of western science. A military surgeon, in full dress with epaulettes, amputates a hand. The whole apparatus with medical assistants, to hold the patient, a tourniquet to restrict bleeding, and a bone-saw to work quickly is displayed. Japanese colour print, c. 1815. British Museum, London (1946. 4–1.04)

40 Eighteenth-century elegance. A Dutch merchant takes his dog for a walk. An Indonesian servant carries his sunshade. Although in full European costume of the period we note that his coat is made of a fine floral batik from Java. Japanese print, early 18th century. British Museum, London (1951. 7–14.017)

41 The hopeful Dutchman comes to market with a very indignant cockerel. This deliberately comical little ivory carving formed a netsuke (toggle) carved from ivory. Japanese, 18th century. Dutch Private Collection

42 and **43** The Portuguese official and his dog shown as frightening ghost figures. One has only to look at the old bearded face to realise that this is a representation of falseness. Perhaps it was due to the memories of the expulsion of the Portuguese under the Shogun Hideyoshi. An ivory netsuke of the 17th century (or possibly a later copy). Japanese. London: sold in November 1966

44 A study in greed. Representation of a Dutch merchant emphasising the strange features of the European. This is a pricket candlestick with a lotus flower design to catch wax drips. Cire-perdue cast brass. Japan, late 17th or early 18th century. Rijksmuseum voor Volkenkunde, Leiden

45 The upright man. This is said to be a portrait of a missionary, and is nearly life size. The shape of the eyes is traditional, as is the use of an adze to give the beautiful surface texture of the portrait. Indians of north-west America, probably Haida of Queen Charlotte Islands. Early 19th century. The American Museum of Natural History, New York

46 The European may be an archetype. This representation of a European was worn by a member of the Gelede Society in the dances in which one might be 'possessed' by a tutelary spirit. This mask was for the use of those who were possessed by the spirit of a white man, which gave power. It is marked by the comb for straight hair and spectacles, but the important symbol of this kind of spirit is the brandy keg. Western Yoruba people from Dahomey; early 20th century. Heinrich Storrer Collection, Zürich

47 The European in the tropics finds that alcohol is a help to him, as well as a useful trade commodity. Carved wooden drum representing the European trader with his gin bottle and glass. Probably BaKongo work; collected in 1843 by Capt. William T. Julio, in southern Angola. Peabody Museum, Salem (E 6754)

48 It's a friendly face but his eyes are shrewd. A portrait bust, life size, of Capt. Zacharias Allewelt of the Danish Asian Company's frigate 'Kongen af Danmark'. This fine ceramic portrait was made in Canton in 1738. Handels-og-Søfarts Museum, Slot Kronborg

49 A keen-eyed Danish businessman seated in a Chinese chair. Portrait of Joachim Severin Bonsach, third supercargo of the ship 'Cronprintz Christian'. Full figure model of clay made in Canton in 1731. Handels-og-Søfarts Museum, Slot Kronborg

50 The sailor learns and meditates. A clay portrait figure of Undercargo Peter Mule, of the ship 'Cronprintz Christian'. This figure was made in Canton in 1731. Handels-og-Søfarts Museum, Slot Kronborg

51 Sea boots, and hands in pockets, a typical stance of the European visitors. The artist has observed costume carefully and shown waistcoat patterns and decorated buttons. The trousers show the change of fashion from the old flap-fronted codpiece to the new fly fronts. Argillite portrait carvings by the Haida Indians of Queen Charlotte Islands, *c*. 1840. Peabody Museum, Harvard (94–57/R 208 and R 198)

52 A Dutchman at the Court of the King of Jakarta. A Javanese wooden painted mask representing a Netherlands merchant. This was used in the ceremonial dance drama which had, in this mask, added a recent visitor to the repertory of mythological characters. Balinese carving of the early 19th century. Central Museum of the Institute for Indonesian Culture, Jakarta

30

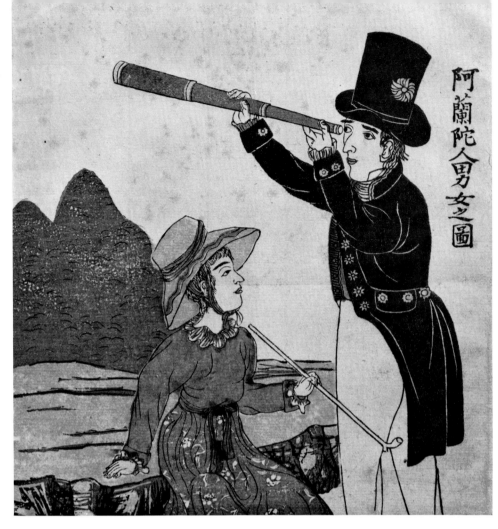

阿蘭陀人男女之圖

31

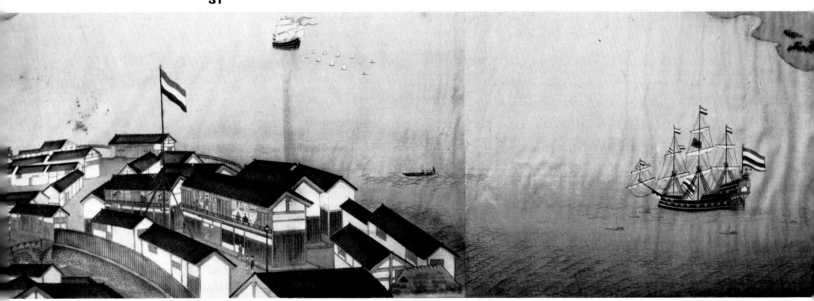

32

33

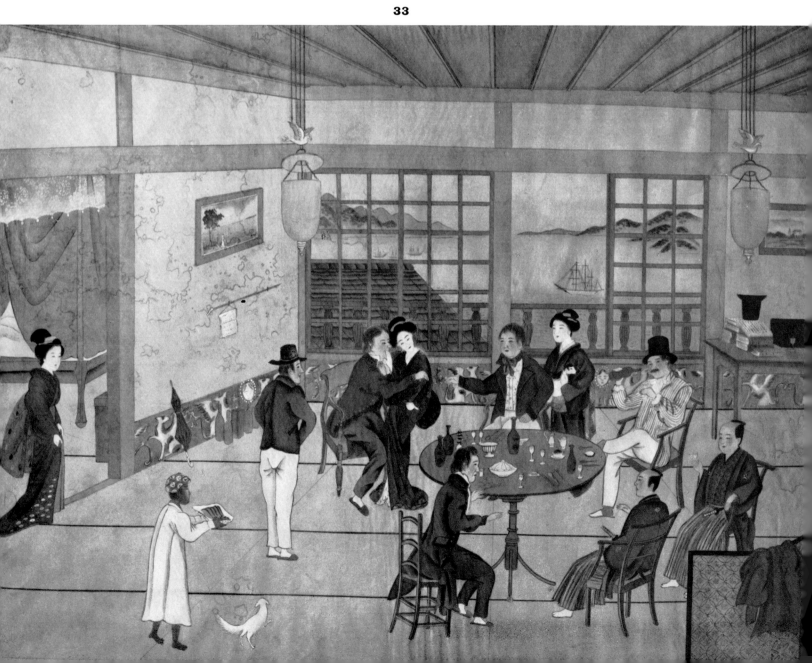

34

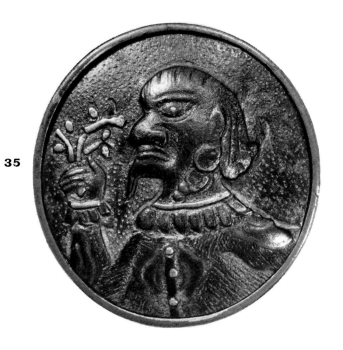

35

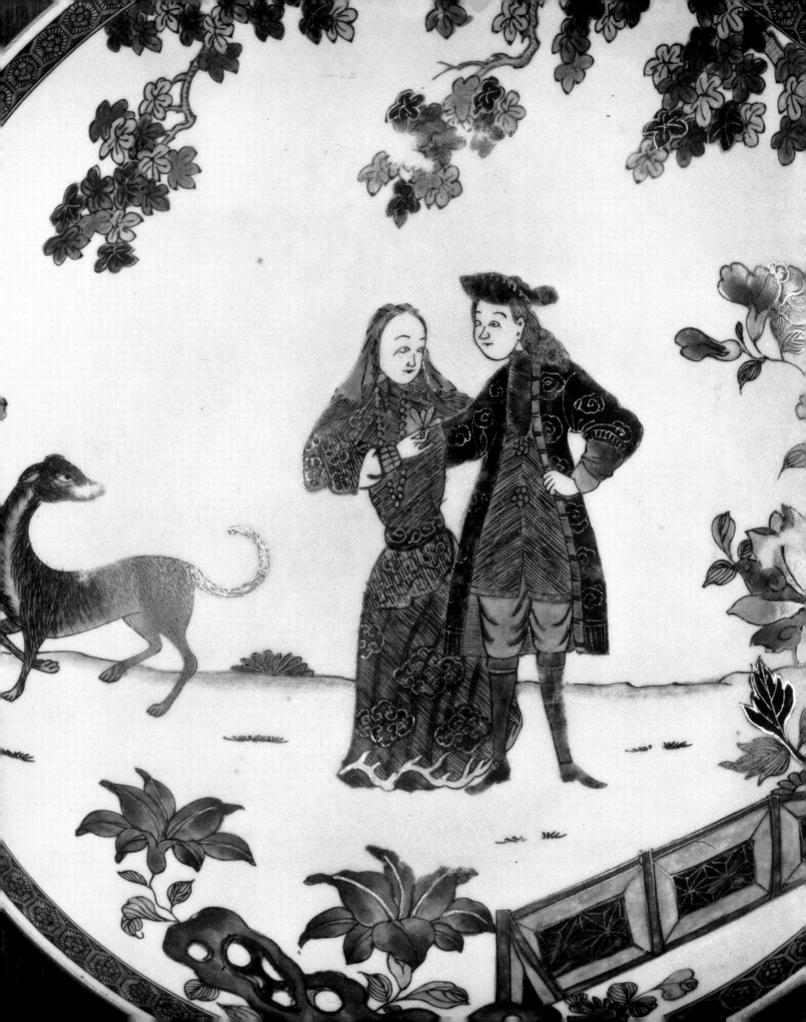

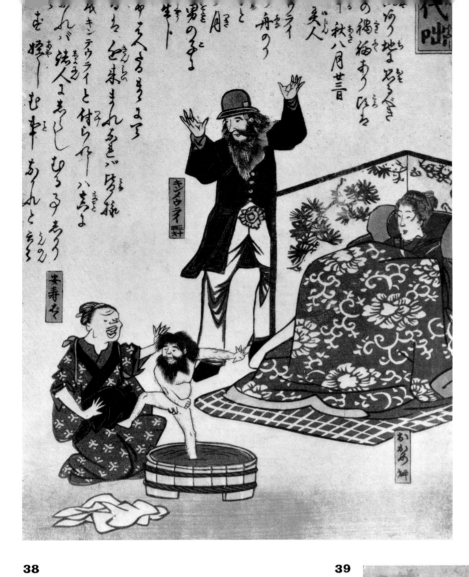

38

39

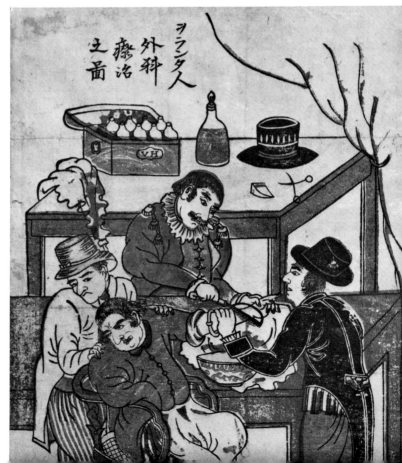

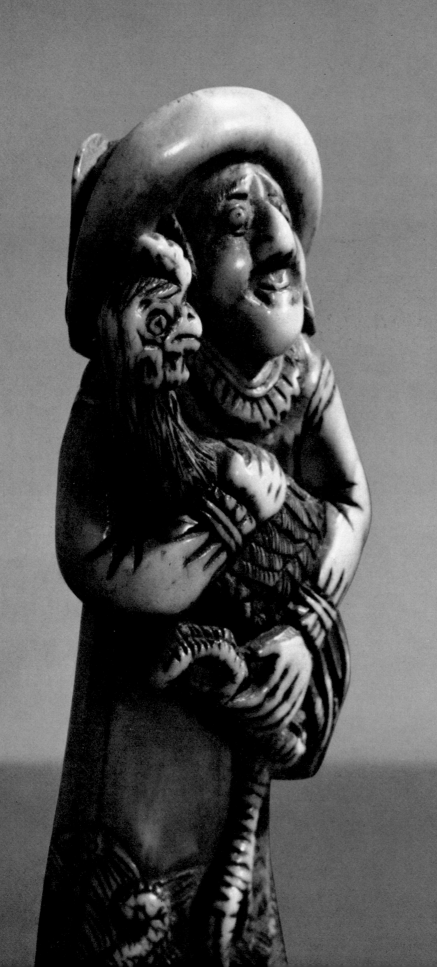

42 43

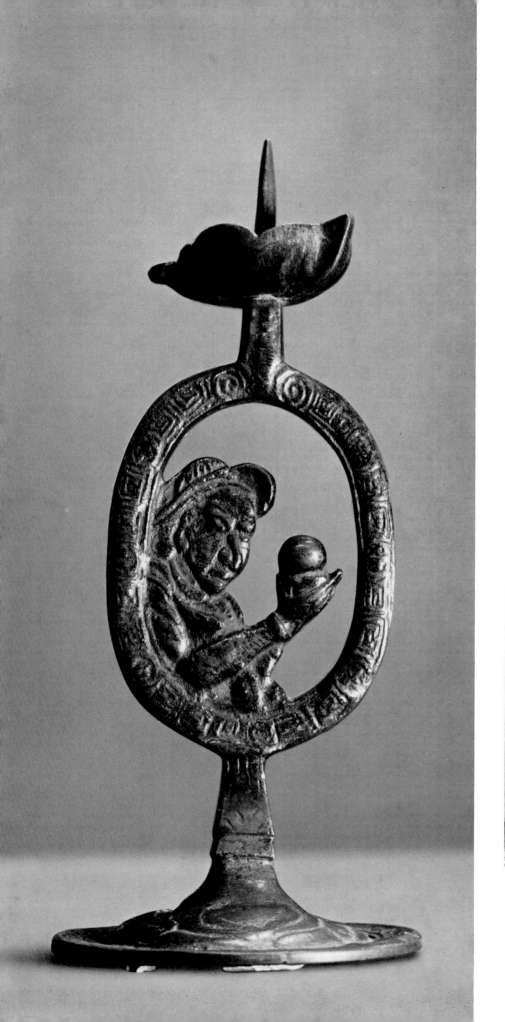

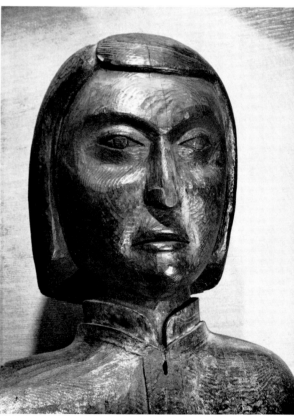

45

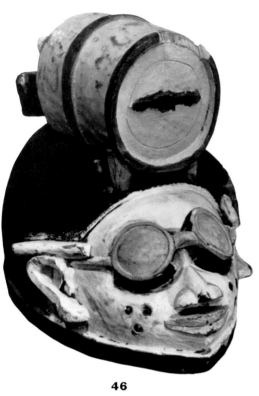

46

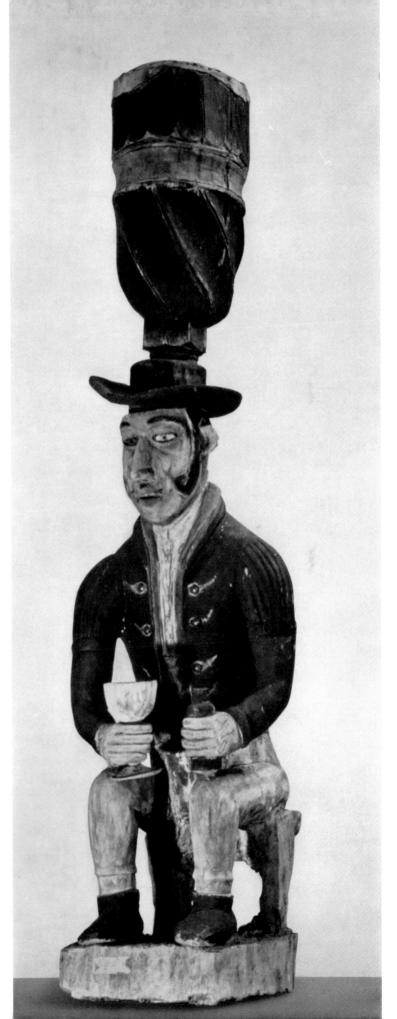

47

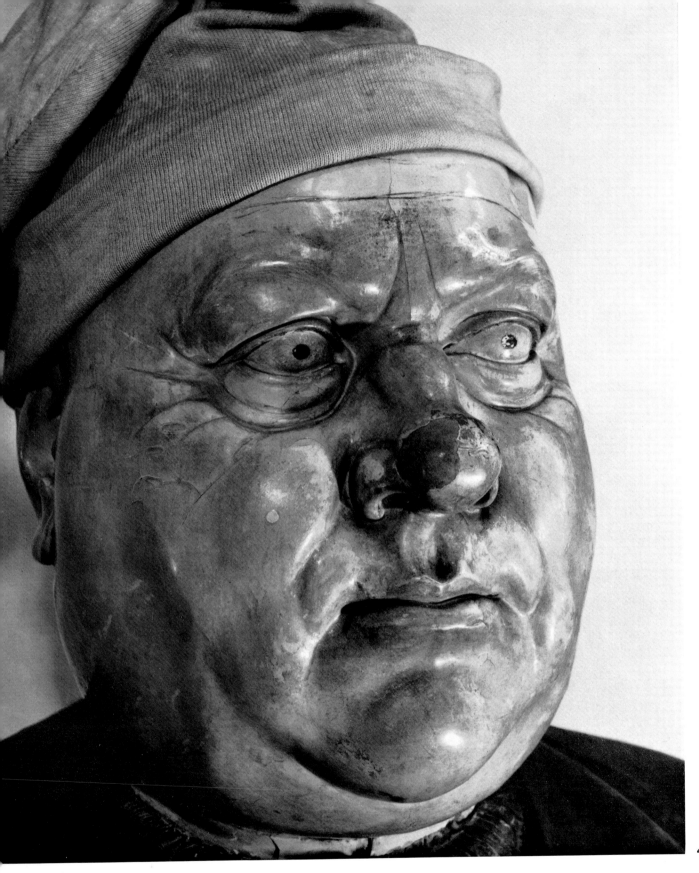

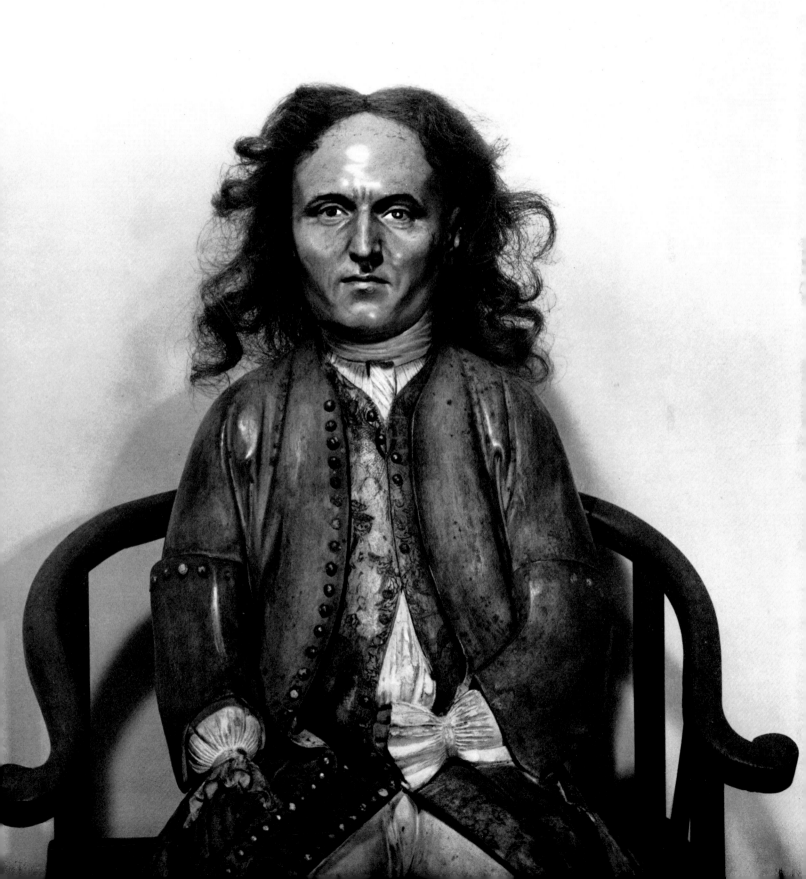

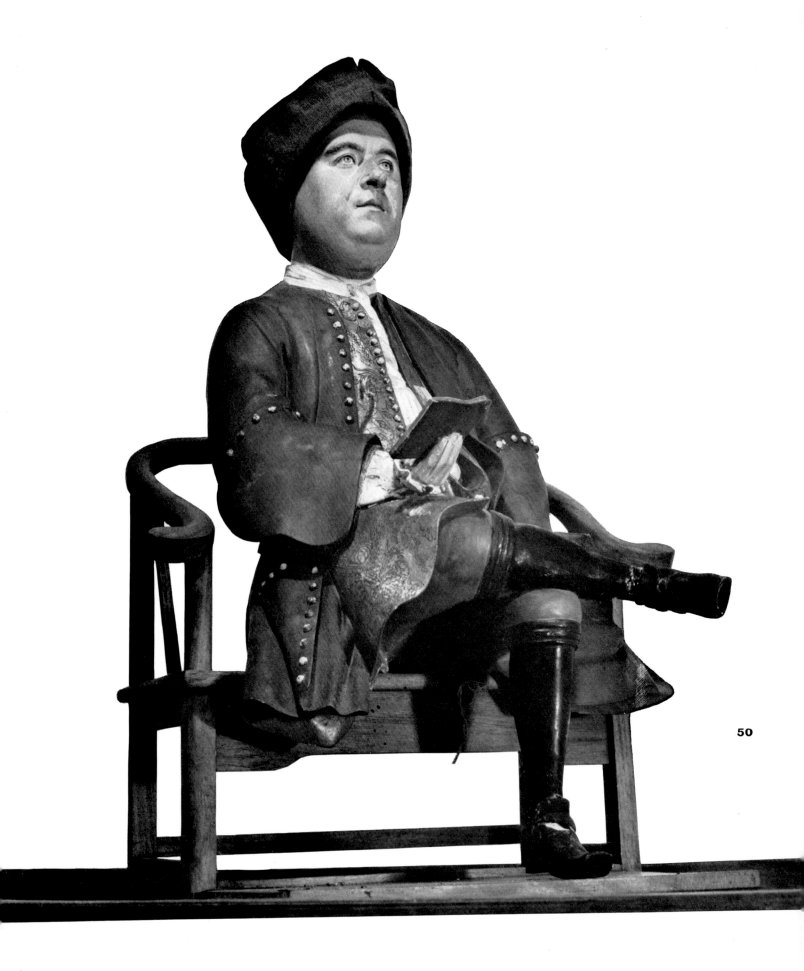

50

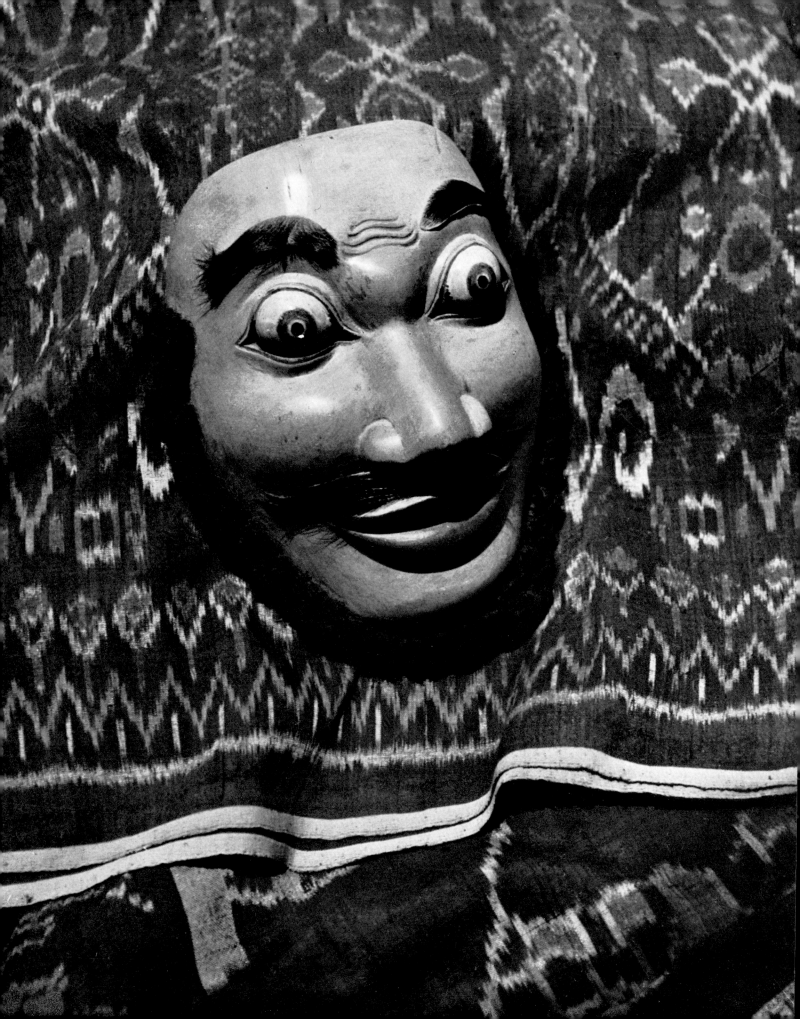

Black Africa

Africa looked inwards. There was no reason for the African states south of the Mediterranean to develop seaborne transport; similarly on the 'east coast of Africa it was the Arabs and not the African people who built up the coastal trading towns. Yet the African nations built up quite wide commercial and political contacts inland throughout the areas of grassland north of the tropical forests. It was just these most highly developed regions which the white man failed to reach until the nineteenth century. The trading ports in the seventeenth and eighteenth centuries opened on to fever-ridden hinterlands through which travellers rarely passed. However, the local people brought down cargoes by river and sometimes on foot with convoys of porters and slaves. The horse did not survive contact with the tsetse fly. Early accounts of voyages to West Africa (plate 6) suggest that it was a wonder that traders and their crews ever returned. It was common for half a ship's crew to die of fever for a cargo of pepper and ivory. Yellow Jack, as they called the fever, slew them with monotonous frequency. For two centuries these low, swampy lagoons and mangrove swamps were truly the 'white man's grave'. The settlements which gradually grew up were merely fortresses protecting trading posts built on higher ground or on more open patches of coast, the forts being used less often to quell African uprisings than to repel assaults from jealous trade rivals.

In the eighteenth century European contacts with Africa were constant, local, and almost entirely concerned with trade. The conditions of terrain and health did not encourage any seizure of land as in North America, or control of native princes as in India, and the internal politics of Europe throughout the century made sure that there would be no peace for the traders as they approached their home ports; both official naval forces and privateers made the life of the merchant hazardous. Hence the continuous low level of European influence in West Africa throughout the period. The most important contacts were well to the south, where Portuguese trading forts at the mouth of the river Zaire, or the Congo as it is now known, were in close contact

with the kingdom of the BaKongo, though, owing to great disturbances in the interior, the power of this kingdom was in decline throughout the century (plates 65, 67).

Trade here was important, but in addition the mouth of the great river Congo provided a good harbour with hilly shores and access to trade routes into the rich forest and savannah lands of the BaKongo domain. The king of the BaKongo became a traditional ally of the Portuguese traders and supplied a steady demand for skins, ivory, spices and slaves, though not on the scale which the West African trade brought in. The better geographical conditions, however, brought about a much closer contact between the two peoples. It is here that we find the king becoming at least outwardly Europeanised, at the beginning of the eighteenth century. His court may have included all the traditional officials of a Bantu kingdom, but now they were clothed in western style robes. The missionaries, always present in Portuguese settlements, made converts, and the kingdom began to present the appearance of a protectorate of Portugal. This did not, however, prevent the establishment of slave traders, nor the occasional violent interference in the internal politics of the area, but on the whole the Portuguese remained near the coasts as traders, and the African king and his nobles administered the inland territory as well as they were able. The true nature of the catastrophe in central Africa which caused the later disruption of the kingdom is not clear. It was followed by similar upheavals over a great part of southern Africa, with only the kingdom of the BuShongo retaining any semblance of unity. Disruption, however, often swept through central Africa; the people were dependent on agriculture, and natural catastrophes were likely to set great waves of people on the move.

It was probably during this period that the slave trade became prominent, when so many captives and victims of war were made available at the trading ports. It was at this time that a court carver of the BaKongo was taken as a slave to be sold in far off Jamaica; here, somehow, the family clung to a slight memory of its former home in the lands of the Congo, managing to remain wood carvers even in the strange conditions of servitude. Their tradition finally came to London through the sculptor Namba Roy.

The same upheavals which reduced the BaKongo to almost total dependence on the Portuguese traders also broke up the power of the kingdom of the Monomotapa in south-eastern Africa. This powerful dynastic king was a chief who ruled several tribes of

farmers and herdsmen from his great stone kraal at Zimbabwe. Such a trading centre, with its long trails reaching out to copper mines, gold bearing rivers, and the plains where immense numbers of wild animals provided limitless supplies of ivory, furs and feathers, was vulnerable to any sudden movement of warlike tribes. Its isolation and decline had already begun in the late seventeenth century, and by the time the first visitors from South Africa reached Zimbabwe, the once busy and active city was almost deserted, the last descendant of the Monomotapa an old man ruling a tiny, straggling village, having nothing to say to the strangers about past greatness. The mystery of his ancestors was preserved, and the white men were reduced to delving into myths which eventually resulted in Rider Haggard's novel, *King Solomon's Mines*.

As a matter of fact the Portuguese had sent a few diplomatic missions to visit the Monomotapa in the days of his glory. They recorded the strange stone buildings and the decorative stonework at the top of the walls which they thought might be inscriptions. Some of the missionaries also went up to visit the great chief. But these contacts were not of any lasting importance. The white man was a trader and he concentrated on the coastal harbours. There was, to be sure, no shortage of material for trade from the interior, but the harbours were of greater importance because they were always open for trade with the highly developed Arab mercantile cities further up the coast. They were also useful depots for the East India ships coming from the Spice Islands on their way to Europe, for revictualling, loading extra cargo, and resting the crews. The extra East African cargo taken on there was sometimes gold or copper but more often ivory and beautiful clusters of ostrich feathers for the adornment of the ladies of Europe.

We have little hope of finding artistic representations of the white man from Rhodesia. The people of the Monomotapa practised a very formal art style, which included animal and human figures but of a simplicity which makes it impossible to identify any non-African figures; then, too, the contacts between the Portuguese and the more cultured courtiers of the Monomotapa were very slight. The coastal tribes who saw most of them were mainly pastoral people who did not make many representational carvings, but even they moved southwards as dispossessed tribesmen from the central Congo swept over the Monomotapa domains.

Further southwards, Africa remained a stone age land, with Bushmen and Hottentots

as the sole inhabitants until the Dutch settlers arrived. Inland, palaeolithic life continued with amazing self sufficiency. The Bushmen knew how to exploit the wild life of the country so as to live in comfort. They used animal skins for clothing and bedding, but they had no traditions of commerce and had no reason for trading with the ships which visited the Cape. Their Strandlooper kinsmen were better known to the settlers, but even with them little real contact could be made. The savages were too far from any way of life known to the Hollanders for any mutual comprehension to develop. Occasionally cattle were killed and raiders were hunted down and shot, but on the whole the contact was one of non-interference on both sides. The Hottentots were the more adaptable, and sometimes they exchanged cattle for European goods. Some of them understood the ways of the farmers around Cape Town enough to work for them, becoming cattlemen and drivers of the teams of oxen which pulled the great waggons from one farm to another, and then down to the Cape where the ships sailed every now and then into Table Bay. The little town had grown into an important centre for revictualling ships. It possessed no native arts and there was only a small amount of trade in skins and ivory, yet the place had a certain romantic appeal and character of its own which soon turned those early generations of Dutch and Huguenot settlers into truly native Africans. Even in the early eighteenth century there was no place in Europe which had the freedom and wide horizons of South Africa. Thus the early settlers on the Cape lived in idyllic peace, trading in fresh food and occasional bunches of ostrich feathers. They were then innocent of gold and diamonds, and were truly *boers*, which simply means peasant farmers. Few native artists recorded these Europeans except some Bushmen in the Drakensberg.

Deliberate territorial expansion was still not of much importance in eighteenth-century Africa. In the south the farms were all that were needed to keep trade going with the ships. In the other parts of the continent, except for Angola, climatic and health conditions prohibited any advance. Missionaries came, mostly from Portugal; their success varied, but we find that the early representations of Europeans rarely include Christian symbols and hardly ever show any figure which one could construe to be a priest. The artist was concerned with the white man as a visitor who brought either trade or terror. Sometimes he saw him as a slaver, though rarely, more often simply as a person who dressed strangely and who drank powerful liquor; he represented with-

out comment these bare facts of cultural contact, facts which make their own comment to us of a different time and place but which in their own time seemed merely records. One cannot now, for example, in the absence of written records, guess whether any of these early images of Europeans were seen by their makers as representatives of spirit beings which could inspire one during a trance (plate 46). This is evident in the nineteenth-century art of Nigeria, but how far one can trace the concept back to the earlier days of cultural contact is not known.

Africa, north of the desert belt, was still controlled by a powerful chain of Moslem kingdoms. On the western coast there were trading settlements of Europeans from the Gambia southwards, but they drew their trade reserves from the Sudan, the great belt of grassland stretching from the Atlantic to the Upper Nile, through which cattle-keeping people passed continuously, trading, building empires, and occasionally sending offshoots south toward the tropical forest belts to found kingdoms among the darker peoples. The west African kingdoms suffered something of a decline in the eighteenth and early nineteenth centuries. This cannot be seen as a result of European infiltration, nor of trade, not even the slave trade, but was a direct consequence of the gradual decline of the north African kingdoms, which was in turn due to the Sahara becoming increasingly arid and so less easy for the trading caravans to cross. The northern trade, on which so much of ancient African culture thrived, was declining. This in turn increased the relative importance of the European traders on the coasts, to whom local kings were forced to turn for wealth from the trade in ivory, gold and slaves.

Disparity in cultural advance between the Europeans and the African kingdoms was another important factor in the decline of Africa. The foreign trader came in ever bigger ships, bringing ever greater quantities of trade goods and armed with ever deadlier weapons. The weapons were an important item of trade. The great chief, with his well-trained army equipped with fine European flintlock guns, now had hitherto undreamt of opportunities for overwhelming his less well-armed neighbours. He could command bigger areas of production for gold, spice, or forest products such as ivory and skins. The victims of the wars were much more numerous as they could now be profitably sold as slaves; gradually the economic emphasis of the area was turning towards the satisfaction of the demands of the foreign merchants. The arms trade helped to keep the

whole complex of commerce, power politics and slavery circulating. At this date the power politics were entirely in African hands, though a sufficiently clever chief could induce the Europeans to supply him with more arms and prestige goods on the assurance of increased trade to follow his eventual victory. The European soldier could not expect to live long in West Africa, so the few military forces were kept in the trading forts, where they were sometimes assisted by native levies. But the forts were not used as bases for territorial aggression, nor to enforce the compliance of the native rulers, as they were in the healthier climate of India.

One sees the influence of this period in the representations of European arms, particularly of cannon and the ubiquitous Dane guns with their flintlocks, on old Ashanti gold weights.

Apparently a great deal of metalwork was carried to West Africa from Europe. In the Ashanti area several fine examples of fourteenth-century bronze vessels have been found, which must have been taken as gifts for chiefs long after they had ceased to be used in Europe. Similarly, copies of chairs and elaborate cups of the seventeenth century have been discovered, the designs of which obviously appealed to the local craftsmen, and a number of pieces of gold work have been found, undeniably of local origin, which show motifs derived from European metalwork. The contact was not in poor quality objects. It is apparent that the traders brought goods of real value, even if in outmoded styles, for the chiefs. In fact it was fully realised on both sides that there had to be a certain equality in the trading system. The materials chosen might be different in value, to the benefit of either side, but the exchange was regarded as equivalent. A particularly interesting case is the importation of brightly coloured and strong silk cloths, which were unravelled by Ashanti craftsmen and rewoven in ancient traditional patterns as robes distinguishing different grades of chief.

Another interesting example of European contact with Africans in the eighteenth century relates to slavery, but probably originated in the use of household servants in the West Indies. It came to Europe in the form of a class of household retainers called blackamoors. In actual fact, these blackamoors were no more than colourful and exotic appendages to the fashionable households of the time, but they lived in comfort in a domestic environment and were usually treated with consideration. One sees them in

the art of Europe as coachmen, footmen, page boys and butlers. They are dressed in elaborately beautiful liveries and seem to be of roughly equal social standing with their European fellows. From the number of times they appear in paintings one may deduce that there were many thousands of them, and that all Europe, especially France, the Habsburg empire, and Britain, was their home. Eventually they seem to have been totally absorbed into the general population, so much so that while in the fashionable London of the eighteenth century they were very much part of the daily scene, a century later the African was so strange that people were rather frightened of him.

Even slavery, although increasing in the eighteenth century, was not quite so severe in its drain on the African population as it became during the Industrial Revolution, which also depressed the condition of the new European proletariat. From the African point of view the change became noticeable towards the end of the eighteenth century. The old trade in captives taken in normal inter-tribal war was rapidly becoming a search for more and more human merchandise to work in the bigger and more highly organised plantations. The merchants began to demand more and more people for sale in the compounds of the slave market. There was a premium on wars and raids to obtain goods for the trade.

The African artist now has nothing good to say about the white men, for he has had precious little experience of them doing good. Bribes, arms, gunpowder, and uniforms, were all brought to West Africa by the European ships; and the various European nations sought to enrich their American colonial plantations by encouraging the marketing of humans. So in art we find the white man, complete with gin bottle and bribes, becoming a more and more common figure. The dancers in ecstatic ceremonies, especially among the slaves in Brazil, found that among the spirits possessing them were white creatures of great power and irascible temperament; so deep had the phenomenon of the white trader penetrated into the African mind that he appeared in this way, as an archetype from the deep unconscious mind of the dancers (plates 46, 47). It was the beginning of an unhappy period, in which civilised behaviour was utterly lost. There was no bloody cult in the swampy jungles of the Niger estuary half so heartless and murderous as the slavery which was being ever more tightly imposed as the eighteenth century came to its end.

Nevertheless the development of the European struggle for social freedom was reflected in the revolts of slaves, which were sometimes successful, as in Haiti. Here the results of cultural contact could be plainly seen. The new Negro societies were no longer quite African, nor were they European. People whose ancestors had been deprived of all education and the most elementary human rights had to build up new social organisations based largely on oral tradition. No wonder many failures occurred and that many cruelties were perpetrated.

Meanwhile all over Africa the ancient kingdoms were breaking up. Culture itself was dying and the close of the eighteenth century saw a new stress in art which reflected the greater uncertainties of life.

The Impact of the Slave Trade

The changes in the relationship between Europeans and other peoples in the later eighteenth century were largely due to the altering political structure of Europe. The previous discoveries of the world had resulted in the increased importance of merchants and bankers. There was more material prosperity spread among more people in Europe. The new social class of the commercial entrepreneur was becoming important. The early investment troubles, like the famous South Sea Bubble, were being superseded by more solid enterprise. Money was available for expansion but it had to be on practical lines which would show a profitable return. No longer was the gamble of the merchant

V The road is forward! A high ranking British Officer instructs his mahout as the elephant swings on its processional path. The European shows only one concession to Indian custom by wearing a jewelled aigrette in his hat instead of more usual military plumes. Indian painting of the end of the 18th century. Victoria and Albert Museum, London (I. M. 447—1914)

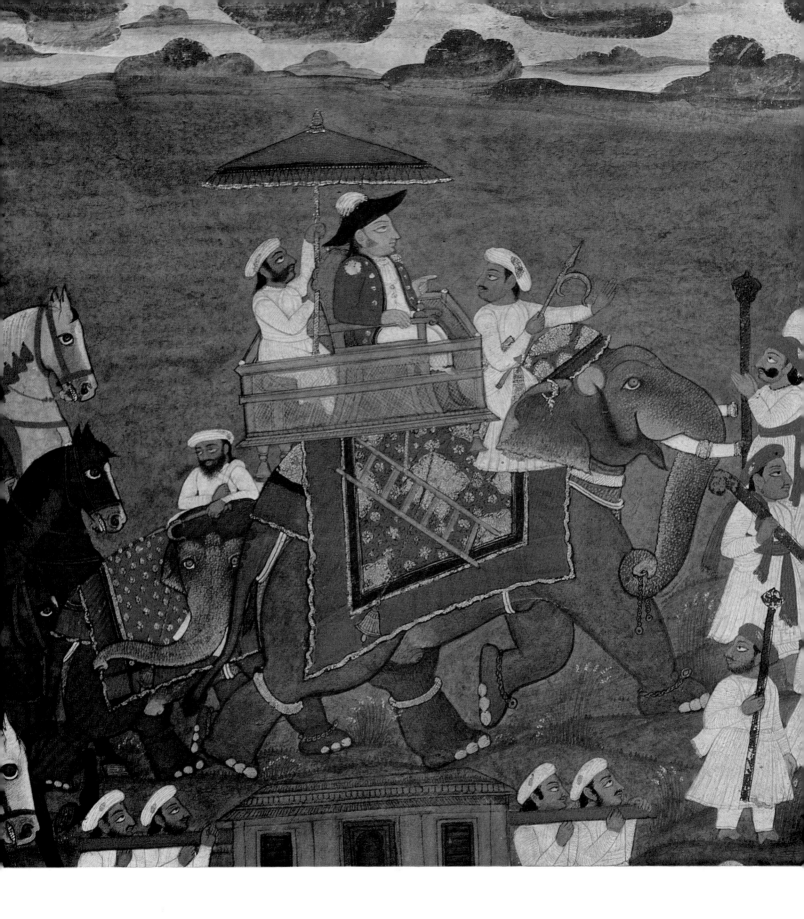

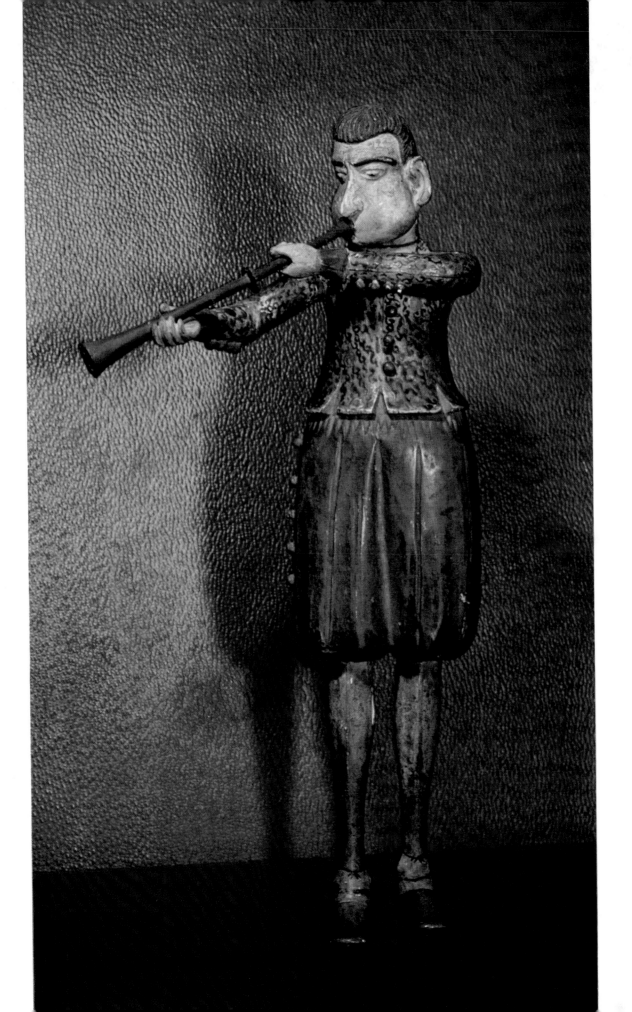

adventurer taken as the proper expression of commercial enterprise. Thus capital came to be invested in industrial production; canals were made to move raw materials to manufacturing districts; machines were developed and installed in factories for the manufacture of textiles, which led to vastly increased production.

The early stages of this Industrial Revolution in Europe and in America increased the demands on the merchants for supplies of cotton, dye materials and oils. Shipping became more organised, and the invention of the steam engine promised to make time-tables more reliable. The regular trading routes to the American colonies and to the Far Eastern markets became much more active, and soon the world was mapped out into regions from which useful raw materials could be obtained at profitable rates and which would purchase or take in exchange the manufactured abundance of the European nations.

This was a vital step in human relations because now the non-manufacturing nations were at a great disadvantage, and it became possible for nations proud of their technical advances to think that their temporary advantage was due to some kind of racial superiority. The idea was not new; it had already been used to justify a great deal of brutality and slave owning, but now it had something to show in the material development of the European and North American countries. What the other peoples of the world did not see was the wave of degradation which afflicted the lower classes in Europe itself. The increased birth rate, a population explosion unprecedented in human history, and the attraction of the manufacturing towns, where money was to be had in return for labour, produced slums of a horror which we can hardly conceive in these days of social welfare. Psychologically the new manufacturing world was not prepared for its own existence, and the ancient impulse of the search for power, together with sheer greed for material possessions, made it certain that human relationships would go wrong, though the existence of human beings with a social conscience made it equally certain that these wrongs would be opposed. Eventually the solution will be based on

VI The ship's boy blows the trumpet. A Japanese view of a Dutchman. The artist has been impressed with the strange big nose and spindly legs of the young foreigner. His treatment of costume is exact in every detail. Japanese wood carving of the Nagasaki school; beginning of the 18th century. W. L. Hildburgh Collection. British Museum, London (1927. 6—11.15)

a scientific rather than on an emotional approach to human problems, but this solution has not yet been reached, even two centuries later.

In the early nineteenth century the world was altering everywhere. The Pacific was newly discovered, and so were the western coasts of North America (plates 51, 60, 61). China was in political decline and the emperors had little authority. Japan, under the rule of the Shoguns, had withdrawn from contacts with other people. India was weak, her Mogul emperors mere figureheads unable to control either their own subject states or the pressures of the East India Company. In Africa we see a disastrous decline in the power of the indigenous kingdoms. The movement of tribes from the forests of the Congo had broken the Monomotapa's power in the south-east; West Africa was torn with internal strife as the larger powers faltered and fell into internecine conflict, a tragedy which probably reflected the decline of the Islamic kingdoms in North Africa and the cessation of cultural contacts across the Sahara. In the Americas the Napoleonic wars had demonstrated to all the weakness of Spain and had set up a chain of revolutions for independence. The North American settlers began to seek increased wealth from the development of farming and the spread westwards was accelerated. In fact it seemed that history itself was conspiring with the shadow side of humanity to develop the worst side of mankind.

In the relationship between Europeans' and other peoples, life was becoming much more organised. In fact there were altogether more opportunities for contact, many of them simply for friendly and mutually beneficial trade. After a long struggle between idealism and profit, slavery was eventually suppressed in the early nineteenth century. The concept of human rights was developing widely, but its exponents had to fight all the way, bitterly opposed by the pressures of expanding commercial self-interest.

Naturally this increase of trade and the ever-growing need for supplies of raw material meant that often the first contact between Europeans and less technically advanced peoples was between the sailors and the coastal villagers. Sometimes violence resulted, and the murder of natives was repaid with the massacre of the visitors. But something close to mutual respect grew up among the Polynesians and their sailor visitors (plate X), and the same thing occurred on the northern Pacific coasts of the United States and Canada. Here, native canoemen were sometimes taken on as deck

hands, there to be treated no more nor less badly than their European fellows. It was not an easy world at any time, but before the establishment of plantations at least the hypocritical practice of 'blackbirding' had not developed. This was the name given to the seizing of men and sometimes women to work on the Pacific plantations as indentured labour after they had been induced to make their mark on a form to confirm that their move was voluntary. One can sense something of the barbarous life of the sailor in Herman Melville's books. The Haida Indians of the north-west coast of America have left us many carvings of the white man, his ships and boats, his wife and children. Sometimes we see Russian and American sea captains in uniform, and sometimes the blocks and tackle of their ships. A whole series of carvings was made about a spectacular accident in which an Indian of some eminence was choked to death by ropes. In some of them his totem animals are shown escaping along the ropes.

In the Pacific Islands we find fewer identifiable references to the white sailor in art, one reason again being that the art styles of the Polynesians tended towards an abstract expressionism, and one cannot be sure whether a particular figure represents a European or a Maori. Even the appearance of a gun in the hands of a figure is no clue, as it could well be a trade gun. The European ships brought guns and quite openly sold them to native chiefs, who were quick to realise that this new weapon gave them an incontestable superiority over rival chiefs. In fact, they used them to such effect that they almost succeeded in exterminating their own people. This happened, grimly enough, in New Zealand a generation before the period of the Maori wars. (One remembers that old-style hero, like someone from a saga, entertaining his friends during the last months of his life by letting them listen to the whine of air entering and leaving the bullet hole in his chest.)

One does not come across the sailor in local art styles very much, other than in the Pacific. The Africans, inland people, were always more interested in the traders, though in the lovely Bini ivory cup in the British Museum a carver has observed the little man in the crow's nest of a Portuguese vessel (plate 6). In Asia too the artists were more impressed by the administrators and the foot soldiers. In other words, it is the sailors who see and recognise their fellow sailors and give them a place in their art.

The last quarter of the nineteenth century does not yield much in the way of naval representation except from Japan (plate XII), where the revival of European trade

contacts is reflected in the strange black shapes of Commodore Perry's little flotilla, and in the news items in the colour prints of the period. But in the Pacific art was in danger of being completely destroyed through the growth of plantations and the consequent blackbirding for indentured labour; the death of all but nine of the Easter Island men who had been brought to work in the nitrate fields of Chile, marked the end of the old religious arts of that Pacific Island. The Alaskan Eskimo, however, learned something of the scrimshaw work of the white sailors and depicted them on attractively engraved bow-drills and dart straighteners.

The other class of person with which the artists of the non-European world came into contact was, of course, the trader. He was useful, but often the artist reveals that he considers the trader something of a fool. He is not always the fierce white man; more often he is the chap who brings useful commodities not made at home in return for skins, ivory and gold which could be easily obtained by the local chiefs who controlled the trade. In particular the artists of Angola excelled in their illustrations of trade with the white man. He is even depicted on ceremonial drums, assuming the status of a powerful fetish in his own right; he conducts trading caravans with convoys of porters over the smooth curve of ivory tusks; he even turns up happily on wooden rattles. Sometimes the artist is obviously amused at this curious creature, but it is also a comment on the darker side of his personality that the artist has also turned the trader into a fetish (plates II, 17, 47). The Angolan people seem to have been keenly interested in representing the European fully dressed. He is certainly a symbol of the gin trade, but not particularly of sex, though sometimes he is shown caressing a woman and in particular stroking her breasts. The white man is not depicted as are the traders in one of the Plains Indian blankets reproduced by George Catlin in his book *The North American Indian Portfolio* Volume II, where they chase the women and display their long penes in public.

The African view of the white man as a sex symbol appears further north than Angola, in the carvings of Nigerian and Akan artists, but the white man is never considered as erotically beautiful as the local inhabitants. Even among the Yoruba Gelede dancers the white man is rather a creature who has clothes and wealth. He has a hat, and often carries such symbols as a watch, an umbrella and a gin bottle. In this he displays the symbols of wealth which impressed woodcarvers as far away as the Nicobar

Islands (plates 32, 62). That is the crux of the matter; in the nineteenth century the European became the trader who possessed great wealth in many exotic and attractive forms. For Africa he was not yet a conqueror or a dominating figure, but a rich man, perhaps even a spirit being from beyond the edge of the ocean. Folk tales tell of his greed, and of how the white-skinned children of heaven cheated the dark-skinned children out of their birthright. Gradually his wealth, and the arrogance which went with it, became resented, and this resentment extended to the white man in general. But he was tolerated because in an increasingly unstable society the wealth he brought still conferred a sense of social advancement on the owner. Sometimes in despair people hoped that in the spirit world they would become as rich and powerful as these pale-skinned strangers; the effigies of the dead in some places in West Africa show them wearing European clothing and with chalk white faces. It was the disparity of material wealth which caused this superstitious regard for the ways of the white man.

It was in India that the soldier entered art. He was the servant of the Company, and he appeared in games of chess as the opponent of an Indian army on elephants. He was the uniformed victim of Tippoo Sahib's tiger (plate VIII). He was painted with the delicacy of Mogul art, or in bold imitation of European techniques. He became steadily more important in the local art because he was the well disciplined tool which unseated local rulers in the interests of trade, eventually placing Queen Victoria on the throne of the emperors. The development of the 'soldier' theme in Indian art followed the natural course of Indian painting, and he became a social phenomenon. The important figures were the princes and generals (plates 23, 25, V), to whom the soldier and his apparatus of war formed a decorative background, exactly as his predecessors had done in the earliest Mogul paintings. Indian attitudes can be clearly understood when we realise that the social status of those Indians in a position to commission works of art was not radically different from the resident Europeans, who were aristocrats and landowners in their own right. The European became part of the internal political structure. The artists devoted as much care and attention to making a commissioned portrait of the resident as when working for the local dignitaries. As with their own people they were gentle and obedient, perhaps excessively polite, but they were still observant and exact artists. The occasional comic element in the situation arose naturally

trom the appearance of the foreigners themselves. It is particularly interesting to note that the Europeans tried hard to preserve the rules of social conduct characteristic of western society, and did not move to meet the customs of those among whom they had found their new home. In the early nineteenth century many Indian artists saw good specimens of European oil paintings, particularly portraits, and they made very creditable attempts to copy them. However, their own style of draughtsmanship was not always suited to the quality of the new medium, and we find the traditional insistence on elegance of outline clashing with the weight of the brushstrokes needed to deal with the oil medium. The carvers had more difficulty in reproducing the features of Europeans, and very often one can note the softer facial contours of the Indian imposed on a figure whose costume and other details suggest that the portrayal of a European had been attempted.

In the first half of the nineteenth century there was little else of this kind of assimilation of styles. Perhaps the closest was the American Indian mission work from the Huron and Iroquois women, who developed a style of flower embroidery in moose hair and quill work derived from the pretty tambour work of their white sisters. It is quite as beautiful, and when translated into European materials in the later years can be identified only by the greater strength of its design. This development is a good illustration of the European attitude to less culturally developed peoples; the native arts were adapted in imitation of European styles. It was simply not realised that the American Indian artistic tradition had any intrinsic beauty or interest, and the artists at the mission schools were encouraged to copy the works of Europe. The Indians also unconsciously cooperated because they thought that the white people, blessed as they were with such wonderful powers and strength, were totally superior, and their works worth copying. The works of Carl Bodmer and George Catlin show how many of the Indian chiefs on the fringes of the settlements took to wearing cast-off European uniforms to mark their dignity and rank.

During this period the Cherokee were to become almost totally dominated by European ideas, and even advanced to the point where Sequoia invented an alphabet to suit the phonetics of the national language. The independent tribes suffered the alternative of either becoming heroic refugees labelled as incorrigible savages, or of

84

having a sort of status in the white community as inferior citizens, imitating the white man and often drifting into his vices, particularly alcoholism. This happened not because of any innate viciousness in either party, but from a simple incomprehension of any other way of life on both sides. The same thing happened in Britain to the Tinkers, travelling people of Celtic origin, often confused with the gypsies, who were really the descendants of the powerful itinerant bands of metal workers of the bronze age. Changing cultural values produced a fall in prestige and a failure to adapt. Perhaps we Westerners tend to blame our forbears too much for cruel and thoughtless barbarity. They had not the sophisticated knowledge of other peoples which modern anthropology and psychology has brought to us. To them the accepted way of life of their own communities was complete and right. That word 'right' led to many difficulties and cruelties, but how many people used the concept to justify themselves? Not the Europeans alone.

The position of missionaries in the early nineteenth century was made deeply ambiguous by the prevailing circumstances. They were certainly not welcome among the slave trading confraternity; in fact in many places slaves were forbidden to hold religious meetings of any kind. Thus there were few mission stations in Africa, though active ones existed in Angola and Mozambique, and also in South America among the Indians, where the Jesuit missions in Paraguay had set a high standard. The situation was similar among the Pueblo Indians of the south-western United States, though here the Indians were to become suspicious of the mission and eventually drive the priests out. But they made many fine carvings for church use before the final breakdown of tolerance. In Africa there were some attempts among the Afrikaner settlers to educate and help the wild Bushmen and Hottentots, but contacts with the Bantu nations were not close at that time. Among the AmaZulu it was the traders who were the first visitors; the missions came long afterwards.

In India the slow progress of the missionaries was made still more difficult by the relation between the official religion of the Europeans and their steady extension of control over the country. The greatest missionary drive during our period, however, was in the Pacific, where many a band of devoted people went out to face the cannibal tribesmen and teach them both religion and animal husbandry. Their success was

remarkable, though many a slip occurred when native converts learnt also of the evil ways of the white men and tried to use the missionaries as pawns in their intertribal wars. Occasionally the European, lonely and unhappy amidst all the attractions of these tropical islands, would renounce the formalities of his faith in preference for the happy polygamy of the islands. It is astonishing to note how these missionaries tried to convert the islanders to European social customs; they were fully under the impression that clothes and framed houses were as much a part of Christianity as the Creed. In their zeal they destroyed much that was good, but they did aim to develop new ideas which helped the people of the South Seas towards a more balanced existence.

In the carvings one sees the figure of the trader and his agent supervising the convoy of manacled Africans. On the east coast there was little representation of the slave trade through the great trading ports; Islam had discouraged the representation of the human figure in art, and many of the tribes had partially adopted Islamic custom and allowed the old representational arts to die out. The Islamic idea of domestic slavery was not so destructive as the plantation slavery in the West, but in the period we are dealing with the trade on both coasts seems to have not only increased in quantity but decreased markedly in humanity.

Missions hardly touched East Africa. It was far away, and the country was altogether more difficult to deal with than West Africa. The coast was mainly controlled by the great trading cities of Arab and Persian origin which had once bought gold from the Monomotapa. In the hinterland the pastoral tribes were comparatively primitive and likely to use violence to protect themselves from strangers, whom they had reason to distrust. In fact, most of Africa was not yet opened up to the white man; it remained a dark world of terror and mystery to Europeans until David Livingstone walked across and up and down central Africa.

VII European naval mercenaries in action in India. The Europeans, probably Portuguese, are painted with realism, though the Indian vessels in which they sail are rendered in a highly conventionalised style. Note that only one man wears armour in the hot climate, also that one boat carries a horse, doubtless for the commander to ride on landing. Mogul painting, from India. Late 16th century. British Museum, London (Dept. of Oriental MSS, Akbar Nama, Fol. 66)

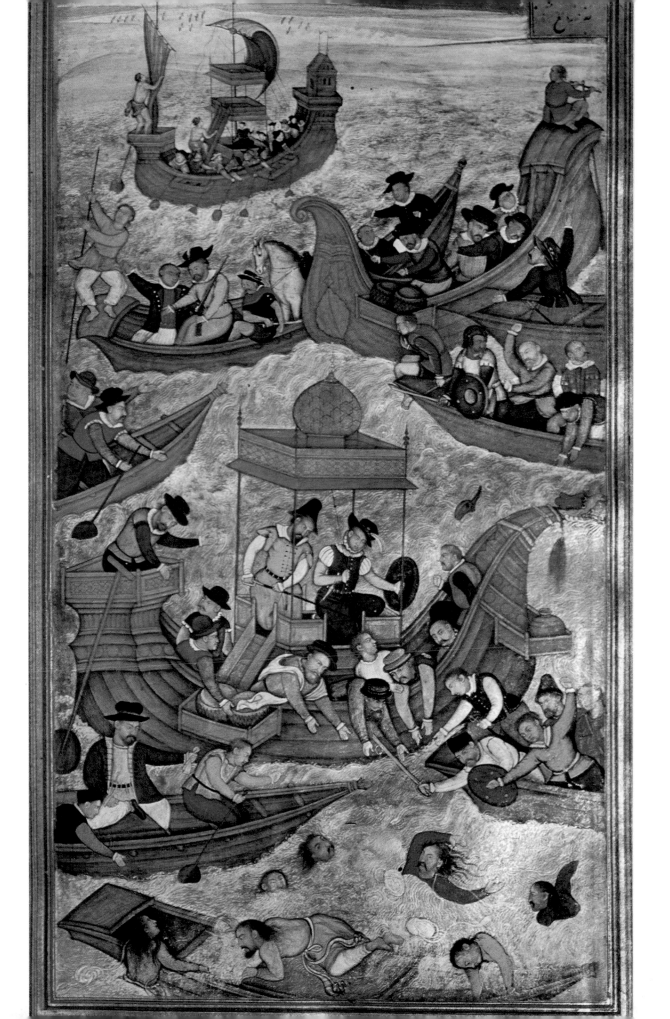

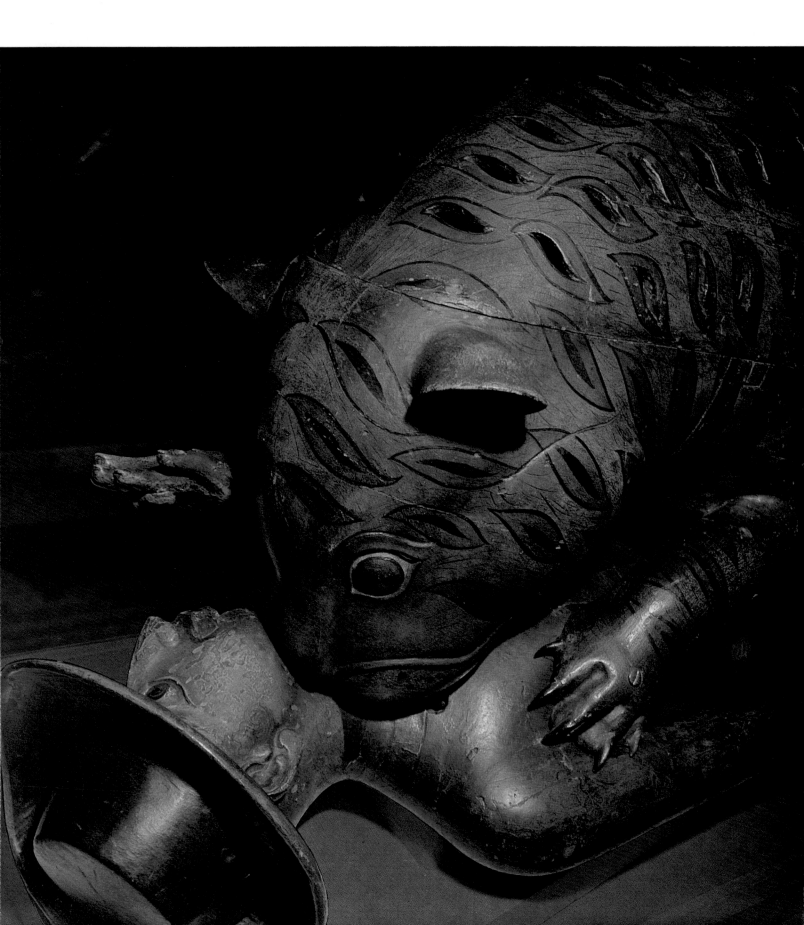

Exploiting Raw Materials

As the nineteenth century developed, contacts between the white man and other races became more numerous and the impact on art more massive. We find the influence of European styles reflected even more strongly in native art, often resulting in a somewhat comical confusion, but we find also that native styles have a quality of their own which given better social conditions might have led to mutual comprehension (plates 9, 11, 14). But the cultural differences between the new industrialised nations and the people still adhering to those traditional ways of life now called 'primitive' were too great for much contact to be made. It was the European who was most bound by his tradition, and it was not until the present century that the artists of Europe began to discover true artistic value in the so-called 'art of primitive peoples'.

The second half of the nineteenth century was not a happy period in world history. An amazing conflict of ideas arose among the newly dominant nations of the earth, who were advancing rapidly in technology but failing to appreciate the social consequences. What this must have seemed like to thinking men among the highly cultured Eastern nations is beyond the scope of this book, but it certainly did not lead to any real increase in admiration for the clever Europeans. Among the artists of the less developed peoples the European is still presented in his different roles. At first there are still the trader and soldier, but towards the end of the period we find the military administrator cropping up; and he is not regarded with very sympathetic eyes. Occasionally we come across examples of the European civilian staffs of the new administrations (plate 12).

VIII The hated rival is destroyed, a kind of magical satisfaction for a prince facing defeat. Tippoo's Tiger. This life-sized wood carving represents a tiger mauling an officer of the British East India Company. It was found in the palace of Tippoo Sahib at Seringapatam when it was stormed by soldiers under General Harris in 1799. The hollow body of the tiger contains a musical organ which represents the noise of a tiger growling while its victim groans in agony. Victoria and Albert Museum, London (2545 I. S.)

The whole of Africa's native culture was deteriorating, mostly because of the new orientation of commerce. Maximum trade was now to be found in coastal traffic rather than in internal exchange. Cash and gold were becoming more important, and these were to be found in the trading ports of the west coast. In East Africa there was less change, but the trading ports were to become more and more important as the Arab merchants discovered that trade with European shippers could be extremely lucrative. The African hinterland became the reservoir which was tapped for raw materials for sale at the ports. It was no longer the seat of powerful kingdoms administering the quiet and reasonable lives of agricultural tribes. The damage wreaked by the slave trade, though the trade itself was soon to be stopped, was irreparable. The wars promoted by slave-hunting gangs to obtain prisoners for sale had completely disorganised tribal society. The raiders and merchants were too often local people, motivated by greed to fill the markets provided by the traders who were inspired by the same motive, called in their case 'commercial enterprise'. The end of the slave trade left broken villages and disunited kingdoms. The passage of the old raiders had left great parts of Africa in a generally chaotic state, but trade routes were more open than before. Alas, guns and powder were the first bulk commodities to be carried up them, no longer for slave hunting, but for wars now and for the seizing of trade goods. In the Africa of this period there was no balance of power, and many small states managed to fight each other ferociously. The foreigners in their big ships still came as traders. They took gold and ivory at good prices, and some of them bought wood carvings and attractive pieces of cloth which they took back with them as native curios (plate 11). The curios aroused laughter in Europe; no one had seen the strange distortions of African art before, and the sexual frankness of many figures produced only nervous titters. Europe had yet to escape from the bonds of fashionable realist art, of almost neo-classical taste. Luckily many of these strange curios were given to museums, and it is due to the uncritical curiosity of sailors that we owe much of our knowledge of African art history.

Although today we are particularly conscious of African affairs, the important developments of a century ago were much further east. The problems of European business were concerned with the production of raw materials to a far less degree and

much more with fostering profitable trade. The Netherlands' East Indies were the source of tea, spice, rice and silk, as well as furniture and ornamental objects. The exploitation of natural resources was efficient and thorough, but the social conditions could not be called healthy. Indonesian and Malayan art of this period depicts the European as a stranger in the country, belonging to no particular class in local terms, but so powerful as to be a separate creature. His ships, costumes and arms make interesting patterns.

In India the foreigner was still mostly a military commander or brightly costumed soldier. Trade was not yet directly controlled by the English, French or Portuguese except insofar as it went by ship. This control was still in Indian hands—which in turn were manipulated by the foreigners, whose military power and wealth dominated the local rulers. The terrible suppression of the Indian Mutiny inaugurated not only the rule of the English queen but also new tendencies in the representation of the foreigner; more soldiers, more railway trains, more symbols of power began to appear. The old court pictures with their smart European visitors gave way to individual portraits of European notables. Small carvings for visitors depicted Indians working at trades as the white stranger might see them, in hand-weaving factories, carpenters' workshops, and working in the fields (plates 22, 27). The small figures of Europeans no longer amused Indian society.

In the Pacific white men began to appear in the art. These were still the days of blackbirding; but in a world in which even the European and American labourers were treated so callously it is perhaps unreasonable to expect the wild peoples of Oceania to have been treated any better. Sailors, marines, ships, straw hats, bottles and guns were the themes of the comparatively few Oceanic art works of the period on which white men were depicted. In the Nicobar Islands, where many ships called, the local designers made wonderful pictorial boards of a kind of spiritualistic magic, on which one could see all the desirable goods which were to be obtained from the visitors.

China had little to say. The merchant princes might have been there (plates 48, 49, 50), but they were of small interest compared with the internal troubles of the country, and the dreadful after-effects of the opium wars. The European hardly appears

in Chinese art except occasionally in woodcuts of the treaty ports. At first, Japan too had little to say, until Commodore Perry and his Russian, British and German collaborators forced the Shogun to open Japanese harbours for trade. When the Japanese decided to study the foreigners (plates 33, 36, 38, 39), they travelled, observed, and produced beautiful prints of the white people and their industrial cities. They soon became acquainted with steam engines and the great trans-oceanic ships. They discovered the European at home in his clubs and dwelling houses. It was an intense and rewarding study, and we have often to feel grateful for this work of those Japanese artists who depicted for us the nineteenth-century world of industry as dispassionate observers.

But not all Pacific peoples were able to adjust to the new state of affairs. The Indians of north-western America continued to depict the white man (plates 60, 61); but their supplies of furs were diminishing and wealth was failing, and the spirit abandoned them as they gradually became absorbed into the urban proletariat. The great days were gone as surely as the buffalo was going from the prairies of their neighbours, the Indians, over the mountains. Here some tragic pictures were made, including the epic of the Little Big Horn.

On a world scale the arts had suffered a great decline. In the industrialised nations there was a certain smug satisfaction; the acceptable paintings were realist in style, or somewhat sentimental after the romantic Pre-Raphaelites and the sad charm of Landseer in Britain or the rich realism of Marees in Germany. Among the unmechanised and dispossessed races artists attempted pathetic imitations of the white man's tradition while sticking to the old techniques, which were themselves in a state of increasing breakdown. It reminds one of another period of political unhappiness and artistic disintegration, when for seven centuries after the fall of Rome, Europe drifted from the old arts without being able to give birth to the Gothic style.

This state of affairs was a great pity, for it occurred just at the period when much of the more interesting cultural contacts between the white races and the non-industrial people were taking place. Collections were amassed, but they were far from being representative, not only because the artists chosen had often been influenced by European styles, but also because the collectors were consciously searching for amusing

curios rather than artistic creations. They were not men like Gauguin, who at least tried to grasp what Polynesia was really like; they were usually so complacent about the rightness of their national versions of what art should be that they failed to see any merit in the creations of their fellows (plate XI).

The world of the later nineteenth century was in fact rushing headlong into moral crises of tremendous magnitude. This is not to be found in our illustrations because the industrial societies were hardly seen at all by the non-industrial peoples. The figures of Europeans were still of traders, soldiers, missionaries, and later of colonial administrators. These people were a mixed bag of creatures. Some were oppressive, but had to be respected because they had the power to kill; some were beneficial, bringing new wealth and desirable commodities (plates 12, 45, 77); a few were devoted teachers. We find many pictures of priests and missionaries in our world of art because some of them were simple souls who knew intuitively how to communicate with the local people, and how to deepen their religious understanding. We find that much of the religious art of the non-industrial people is penetrating and profound. Not all missionaries were so narrow as to force their followers to copy the pretty sentimental angels and plaster saints which made European churches a wallowing ground of sentimentality in this period (plates 63, 64, 66). A small cast brass saint (plate 65) from the Congo is artistically more meaningful than the whole gamut of European religious carving of the time. In this field alone do we find an advance, since it was one where the inner personality stirred into life despite the harsh outward influence of the materialist world.

As the century advanced, the needs of the industrialised nations continued to increase. The continuance of their way of life demanded ever greater supplies of raw materials, the source of which was, of course, the tropics. Thus the small plantations of copra, sisal and oil palms in the Oceanic islands had to be reproduced elsewhere. This led to the exploitation of rubber; first the native rubber plants of South America and then the plantations in the Congo and Malaya. The exploitation of metals was also of rising importance. Tin became of greater importance than ever before in the making of bronze. The electrical industry developed and copper was much in demand. Mining companies joined with the other traders in obtaining concessions from local chiefs,

particularly in Africa; and it was not long before a *fracas* arose, European governments intervened, and protectorates were established. Many such protectorates had a good influence on the life of the local people; there was much more wealth going around and there was a great deal less inter-tribal warfare. The carvers and painters found new themes, and we find some most amusing and attractive representations of the pompous foreigners, of the sharp-eyed teachers, and their curious social customs (plates 70, 74, 75, 76, 78). One carver managed so lively a representation of a high colonial official standing hand in hand at the races with his current girl friend that it became a matter for teasing in the clubs a generation later. The African artist, it seems, was directly involved in all this new life. The carvings are often friendly and give intelligent comment, and one is led to understand that the artist was freely translating life as he saw it at the time. There was little true political comment. In fact this could not come until education and a wider transcultural understanding of human affairs had matured in Africa.

The period of struggle among the powers for colonial possessions was not a pleasant sight. It involved intrigue and jockeying for position, and attempts to make the colonial people into instruments of policies aimed at domination of world trade. The Africans, or so their works of art imply, had until this time seen the white man as not a bad chap, but somewhat over-supplied with soldiers. In fact by the end of our period the struggle for a place in the sun was leading the world towards a great upheaval, in which frighteningly little consideration was given to the native peoples of the tropical regions. It was a period of maximum impact on the artists (plates II, 58, 59, 70). We find the whole panoply of the white rulers in native art. The European rulers are portrayed almost fetishistically, worshipped by bowing and saluting on the part of the dignitaries—the governors and political agents. It was the period of machines, of the bicycle, sewing machine and steam train; they all called for representation. Sometimes the white man was regarded with such awe that he was taken as a model for the blessed dead in Heaven. In Panama we see the white angel with his gun. Among the Ibo the spirit houses show the souls who visit them in the guise of white men eating and drinking as the ruling race were seen to do on earth. Much good and much evil came out of it. But it is noteworthy that a similar artistic phenomenon occurred among the

94

53 The Dutch trader touches his hat in welcome. The artist is using a traditional basic pattern for his European, but has given the figure a life of its own. This relief carving was made on a section of a large bamboo intended for use as a bucket. Japanese work, mid 18th century. Rijksmuseum voor Volkenkunde, Leiden

54 Time to close the account books. A Dutch textile merchant checking his accounts, with the rolls of cloth on the table in front of him. The table cloth is a piece of Javanese batik. A Japanese colour print from a woodblock of the early 19th century. British Museum, London (1946. 4–1.02)

55 Life with the European can be very pleasant. A well-to-do gentleman with his Japanese wife. She has already adopted European fashion, although the hat seems to have been adapted to a more Eastern style. A woodcut from Japan in the mid 19th century. British Museum, London (1951. 7–14.034)

56 Domesticity in a mixed household. The wife looks at the portrait of her foreign husband, now far away. Japanese colour print from woodblocks of the late 19th century. British Museum, London (1951.7–14.029)

57 A gold lacquer screen in which only the margins show its Oriental origin. A view of the inner harbour and drawbridge said to be Amsterdam. The artist has presumably worked from a European engraving and has adopted the convention of perspective with great success. Chinese work of the mid 18th century (the period of Chinoiserie in Western art traditions). C. T. Loo collection, Paris

58 A symbol of power and protection. Victoria of England shown in a highly conventionalised style of wood carving, made freehand, but based on turned wood patterns. Sierra Leone, probably Mende work, late 19th century. Horniman Museum, London (O.N/N)

59 Another of the divine images which gave the white man his magical power. Kaiser Wilhelm II of Germany in military uniform. Note that the artist has observed the shrunken right arm of the Kaiser simply and without exaggeration. From Tanzania, early 20th century. Horniman Museum, London (13.5.63/6)

60 This is said to represent a missionary and his wife. The details of the dress and the expressions of the people are observed carefully, but traditional art is strongly marked in the construction of the faces. Carving in argillite by the Haida Indians of Queen Charlotte Islands, mid 19th century. British Museum, London (Christy Collection 9392, acquired 1875)

61 Europeans, who seem by their costume to be Russian settlers in Alaska. The simplified expression of form is ideally suited to the heavily grained pine used by the artist. The forms are more traditionally Indian because of the tribal traditions in art being stronger and more direct than among the Haida. Tlinkit carving from southern Alaska. First half of 19th century. American Museum of Natural History, New York

62 The beginnings of a cargo-cult. In the centre of the carved and painted board is home, a Nicobarese hut on piles. A canoe and a ship lie beside it and birds fly around. Below is everyday wealth; a fine herd of pigs. Below that again there are the creatures of the sea. But above is a great spirit-being with a top hat. His face is white and all around him are the things of the white man: tables, pens, knives, guns, mirrors and lamps. The dream world of riches belongs to the magical white man. Nicobarese votive board, late 19th century. Rijksmuseum voor Volkenkunde, Leiden

63 It seems as if some kindly but determined young Irish nun had been the model for this carving of Our Lady Queen of Heaven. The quiet intensity of devotion makes this an important religious statement although carved only in soft wood. BaDjokwe carving, early 20th century. Musée Royal de l'Afrique Centrale, Tervuren (No. 55.95.128)

64 The new people have brought their gods and one begins to realise that they are not altogether like most people. Here is a saint in prayer. A factual statement from carvings seen in church at the Mission. Minumgu carving from the southern Kasai-territory, early 20th century. Musée Royal de l'Afrique Centrale, Tervuren

65 The ecstasy of the Transfiguration. Christ in the Garden of Gethsemane with the shadow of the Cross around him, prays inwardly and upwardly. This is a work of power not unlike good Romanesque art in Europe. From Angola, of the 17th century, a brass casting. Musée Royal de l'Afrique Centrale, Tervuren

66 The apparition of Our Lady of the Rosary, perhaps taken from a picture of Her appearance at Lourdes. The white-faced figure sweeps forward in a deep contemplation, almost like the moon apparently sweeping through the clouds. It is an African translation of an idea which in all likelihood transcended the plaster saint seen in the church. From the southern Congo, early 20th century. Musée Royal de l'Afrique Centrale, Tervuren

67 A little saint, a monk with a breviary, walking in his simple garb intently towards the future. Perhaps St. Francis. This is an extremely rare and early sculpture from the Southern Congo. BaKongo work of the 17th century. Morton Simpson Collection, New York

68 The cyclist has control of his machine, and concentrates on the road ahead. His coat is a smart tweed. The artist has been able to deal with the whole subject with the exception of the propulsion; though he suggests the movement of pedals very well. However, he is not concerned with details so much as the personality of the

rider. Wood sculpture from the Bakuba, early 20th century. Musée Royal de l'Afrique Centrale, Tervuren

69 Clothes for me, and you and all the family. The immeasurable boon which the sewing machine brought to the women in tropical villages deserves more than this little portrait. But here it is presented with great simplicity and truth. Soapstone sculpture of the Mboma-people, 19th century. Musée Royal de l'Afrique Centrale, Tervuren

70 and **72** Speed, accuracy and power are all under the control of this Belgian magnate and his chauffeur. The personalities in motoring are involved in this work where the artist understands the qualities of the people more completely than their machine. The treatment of headlights, running board and wing stays links the idea of the car with a railway engine, though probably without any conscious planning. Luba-work of Katanga (Congo), early 20th century. Musée Royal de l'Afrique Centrale, Tervuren

71 The great river has been tamed by the strangers. They have made river boats for transport and trade, and designed them with shallow draught so that they can negotiate difficult stretches of shallow water. The artist has omitted neither the name of the boat, nor the rope needed to tie her up at the wharf. It was made very simply as a toy. Ba Teke-work, Congo, early 20th century. Musée Royal de l'Afrique Centrale, Tervuren

73 Even the English pottery group from a cottage mantelpiece has found its way, perhaps in the baggage of a missionary, to cheer the people of a distant tropical village. This group of a Highland family at the well is typical of the little stoneware figure groups common in mid-Victorian Britain. The African artist has copied it with unusual fidelity, perhaps because its simplicity appealed to him. He has even made a reasonable attempt at a tartan kilt. Tribe not recorded, but collected in the Congo. Musée Royal de l'Afrique Centrale, Tervuren

74 Madame, with teaspoon and plate in hand wears the latest European fashions. Yombe work from western Congo, early 20th century. Musée Royal de l'Afrique Centrale, Tervuren

75 The master is rather well groomed, wears shiny glasses, expressed in a clever simplification, and shows his personality in his gay patterned jacket. Ovimbundu carving from Angola, early 20th century. Musée Royal de l'Afrique Centrale, Tervuren

76 Portrait of a Portuguese merchant, expressing a civilised enthusiasm, seen during a visit to the Congo. Ovimbundu work from Angola, 19th century. Musée Royal de l'Afrique Centrale, Tervuren

77 The White Father has a fine black beard, and he is seriously thoughtful and well poised. A man to respect. It is the portrait of the missionary and ethnologist P. Léo Bittremieux, who died in 1946. Woyo work from Moanda (western Congo), 20th century. Musée Royal de l'Afrique Centrale, Tervuren

78 The military administrator takes a record. He is very smart, very upright, and slightly nervous in company. Soapstone-sculpture of the Mboma-people (western Congo), 20th century. Musée Royal de l'Afrique Centrale, Tervuren

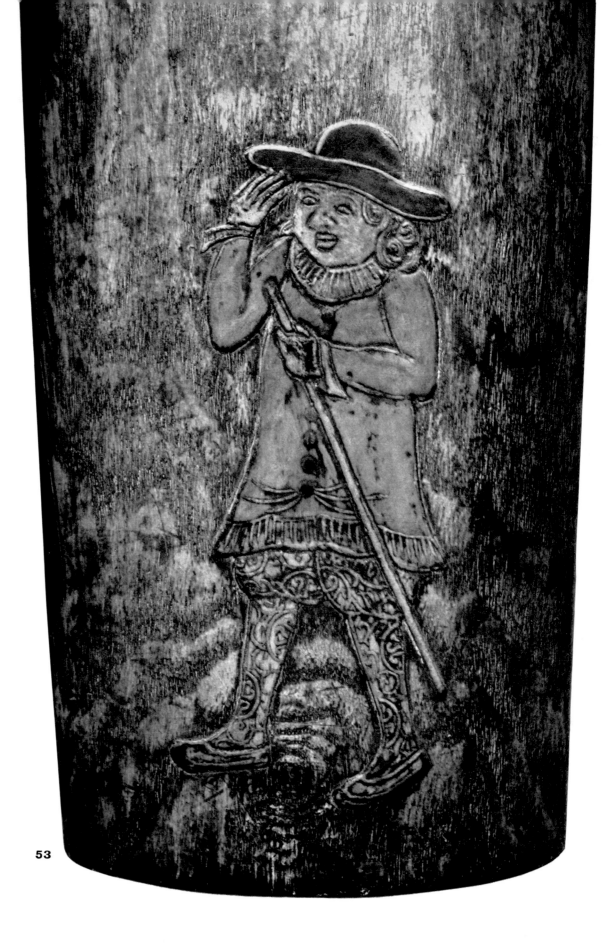

53

阿蘭陀人之圖

54

55

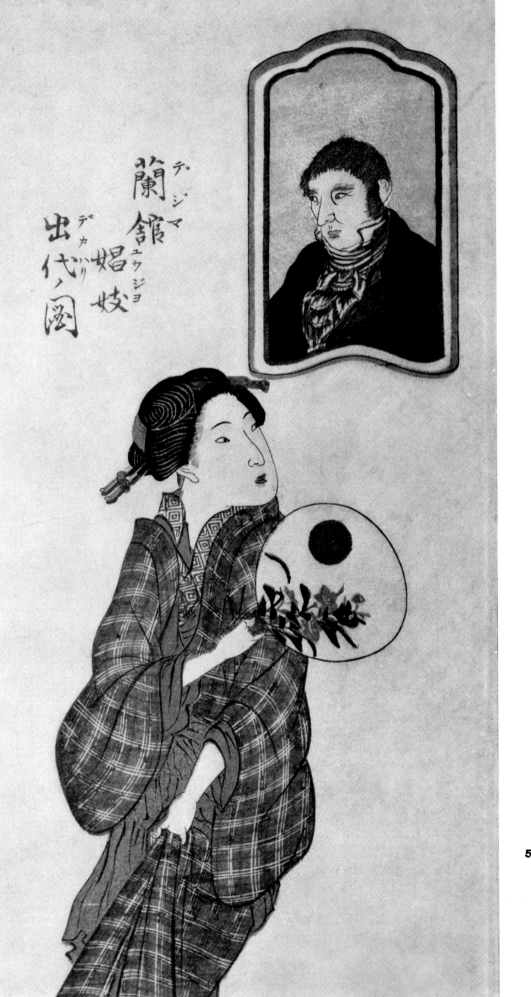

蘭<ruby>館<rt>テ</rt></ruby><ruby>娼<rt>ジ</rt></ruby><ruby>妓<rt>マ</rt></ruby>
<ruby>蘭館<rt>ランカン</rt></ruby><ruby>娼妓<rt>シユウジヨ</rt></ruby>
<ruby>出代<rt>デカハリ</rt></ruby>ノ圖

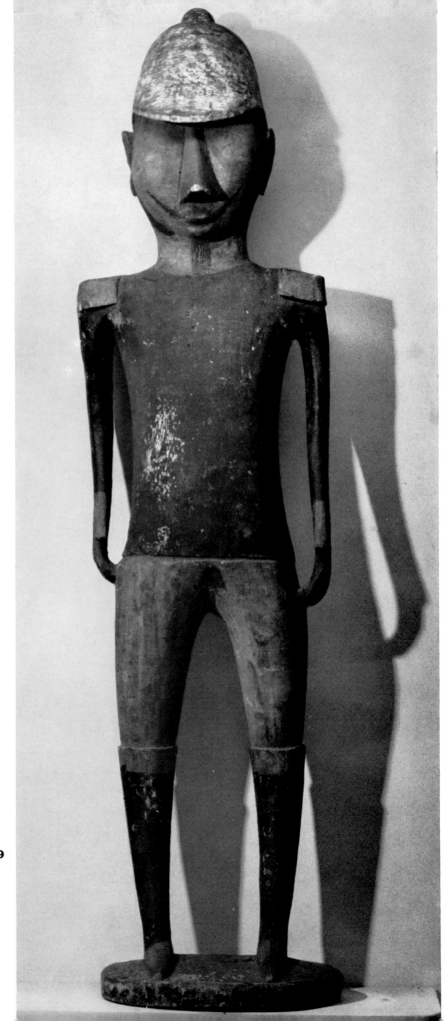

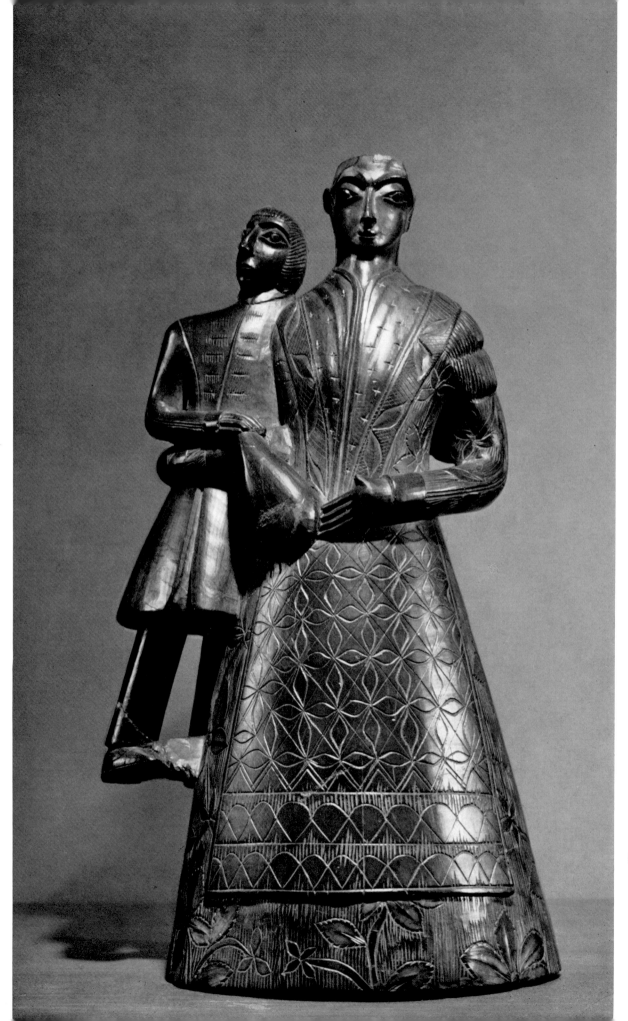

60

61

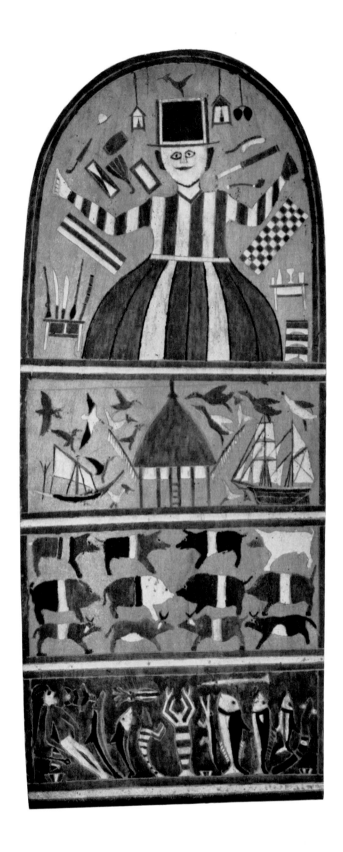

62

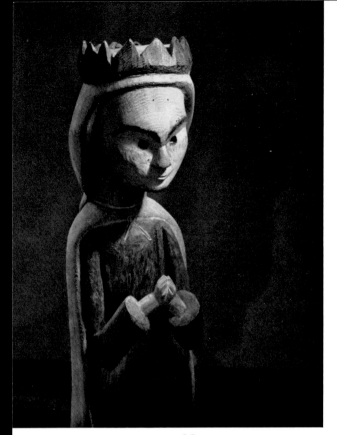

63

64

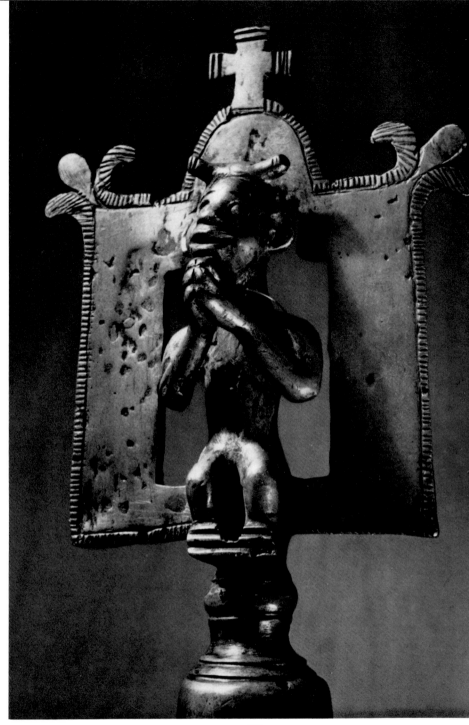

65

66

67

68

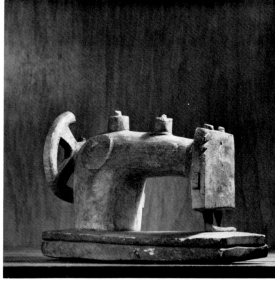

69

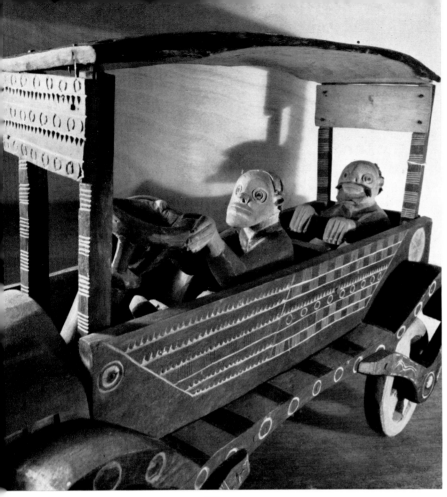

70

71

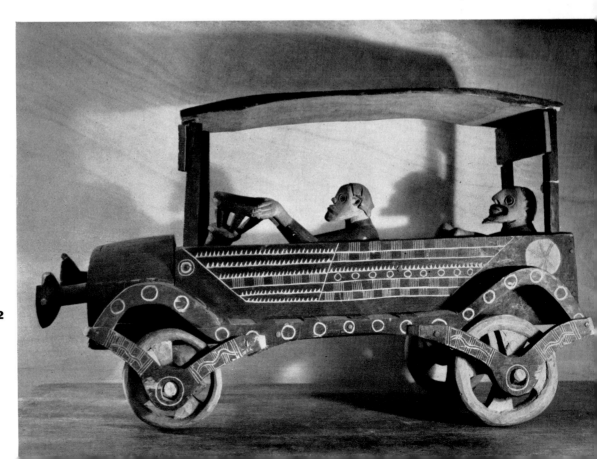

72

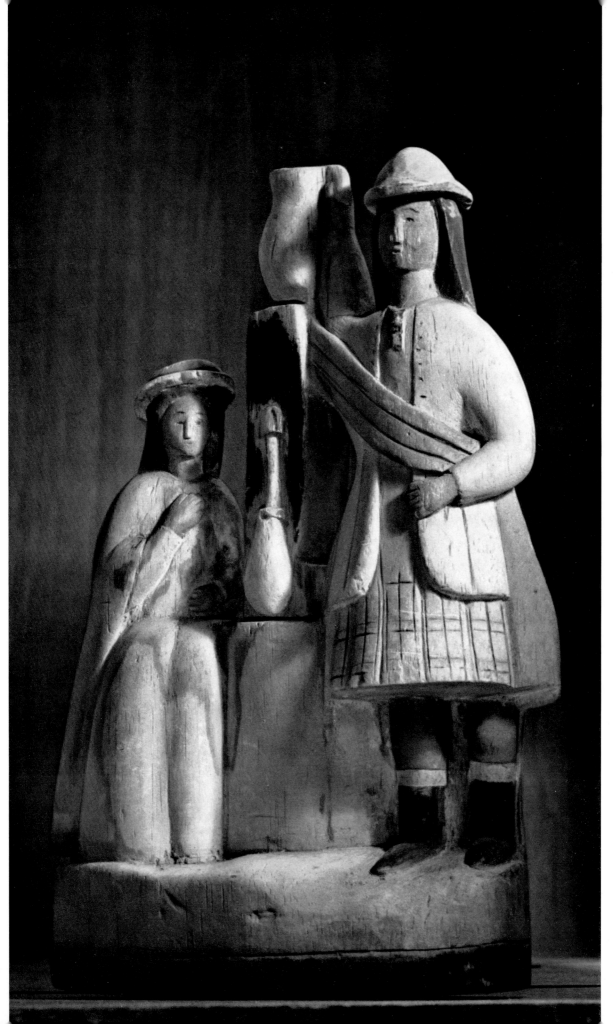

73

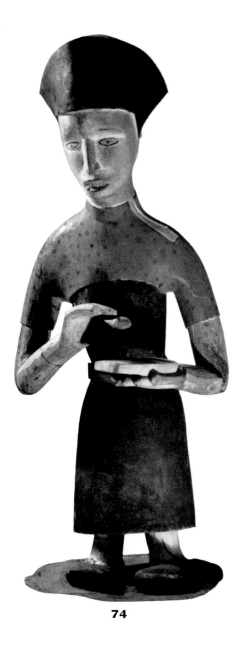

74

75

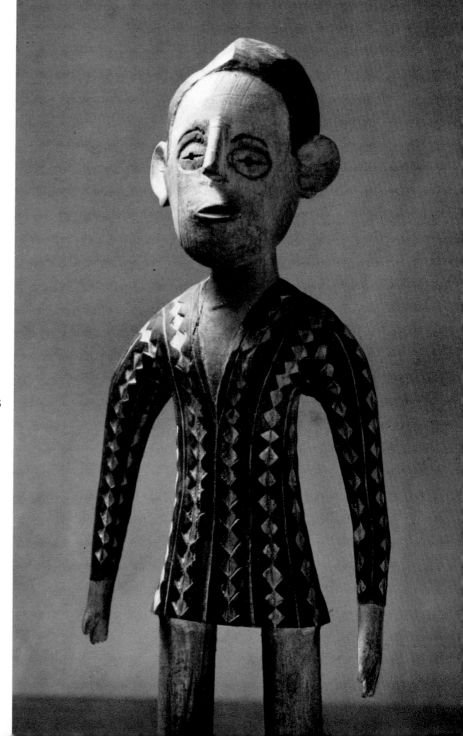

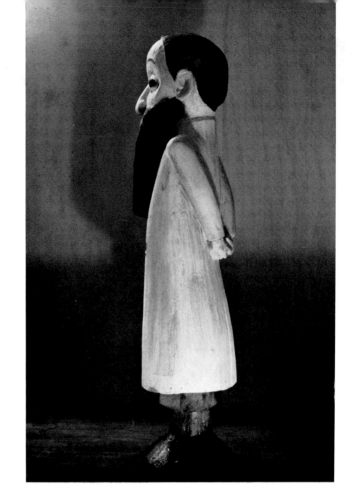

77

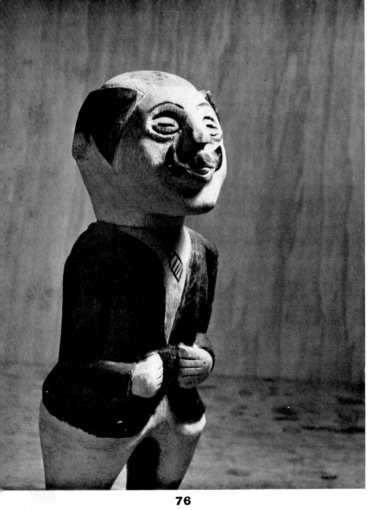

76

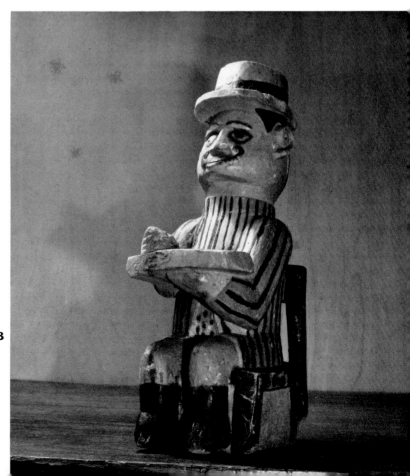

78

American Indians of the north-west coast about a century before. There, the white rulers appeared on totem poles; small carvings depicted the Europeans as fascinating strangers who lived an incomprehensible life of their own. But this rather agreeable aspect of their art came before the total subversion of the native culture. Perhaps this nearly happened in Africa. It certainly came near to happening in India where British rule was accompanied by better organisation and a seemingly irreversible decline in art and native culture.

From the historical point of view we have been concerned with a period of increasing contacts between the foreigner and the local people, a period in which the growth of the industrial powers caused drastic changes, leading eventually to the domination of the tropical peoples by the northerners. Art does not reflect this great movement of history at all clearly. The artists with whom we are concerned were aware only of local events; they expressed their personal opinions of what they observed. Their art is basically tribal in nature and individual in expression. It does not assume that the foreigner is either bad or good. On the whole, he is shown in his more attractive aspects. Few people seem to have resented the slave traders in the way the Angolan artists of the BaKongo depicted them on their ivories. Few people escaped the subversion of their own beliefs; they realised that Christianity was not always a political trick, but in the Congo there was an understanding of the inner truths of the matter. Practically no one except the Congolese realised that the urge for personal gain and the greed for cheap labour and mass production were destructive of the human personality. The artists saw immediate facts, and very often those facts were profitable to themselves and their families. It is an interesting thought that the artists among the white men were similarly blind to this great movement of human history. A few discovered 'primitive art' and studied it, because they saw that these methods of apparent distortion expressed the inner state of things. But while observing the strength of the artistic powers among other races they did not see that their own world was changing, and that in its great power and material success it had the seeds of a destruction of unimaginable magnitude. Like the African artists they recorded the immediate impact of the world upon them.

The Tools of the Artists

The impact of European civilisation did little for the development of tools in any part of the world. The craftsman and artist are by nature traditional because the use of the tools to which they are accustomed produces good work without the necessity of learning a new technique. The introduction of steel instead of stone was accompanied by practically no change in the form of the tools used. Adzes were fitted with metal blades instead of stone ones in New Zealand and on the north-west coast of America. Chisels differed little; the hard, stone blade set in a wooden handle lashed tight to prevent splitting was simply replaced by a steel blade set in its handle and clipped with a brass ferrule instead of the lashing. It was the same tool and it was handled in much the same way. In some ways steel was inferior to stone, since in primitive conditions it was somewhat brittle. One remembers that when the last battle between the Vinlanders, led by Thorfinn Karlsefni, and the Skraellinger was beginning, the Indian tribesmen laughed when a Viking sword broke on a rock and their own stone adze simply split the rock. Then too, stone tools left lying around did not rust as steel and iron did. And it was not all that advantageous to use steel. Recent experiments in the New Guinea Highlands showed that the older men of a small tribe who remembered how to use stone adzes were able to cut down a tree in only twice the time which was taken to fell a similar tree with a steel-headed axe.

Metal tools were better understood among peoples who had used bronze before the introduction of iron and steel, and the new material was enthusiastically adopted in Mexico and Peru. In Africa, where the native iron was worked in all regions of the continent north of the Bushman hunting grounds, little was gained by the introduction of steel. It wore better, but it was not so adaptable as the softer home-made product. Only as the need for tools increased through the approach of industrialisation in the early part of the present century was there any great increase in the use of steel tools; and even then the local artists usually preferred the old material which they knew better how to manipulate than the too hard steel.

As far as the artists of Asia were concerned, there was no Western technique which proved desirable to them. In India there was for a time, as we have seen, a market for oil portraits in which Indian artists depicted officials and military men in European style, but it is not a rich field of art to explore. The real beauty was to be found in the surviving techniques of the various schools of the Mogul tradition. In sculpture the production of fine steels supplied all that was necessary for any artist. The same considerations applied to the Islamic world, but Islamic art is hardly represented here, since the early teaching was definitely aniconic, and the artists therefore were not concerned with direct representation of living beings, whether European or not.

The contacts with Europeans had most effect on local art styles through providing a market for reproductions in the more civilised countries, and for curios in the more primitive. India, China and Japan produced really fine portraits of Europeans seen directly and treated in the more naturalistic of their native art traditions (plates IX, XI, 33, 36, 39). We find the result pleasing because the artist has not deserted the artistic traditions which he had learnt in his own community and was therefore able to deal with a strange subject just as faithfully and directly as he would a local dignitary of his own home town. The tendency to keep closely within local traditions in art reaches its other extreme in New Zealand where there are to be found portraits of Europeans, in symbolic form, in which the dignity of the subject is indicated by the spiral facial tattoos which indicated the social standing of a Maori of the highest rank. Unless there is a traditional attribution of unquestionable authenticity, it is impossible to distinguish such Maori carvings from representations of Maori ancestors. The converse occurs among the Ibo of West Africa, whose representations of ancestral spirits may be dignified by being dressed in the socially important accoutrements of the white man, but whose faces are painted white because that is the colour of the world of spirits. Here we find the distinction between the races is lost because of the approximation of the representation of spirits to the outward form of the foreigner.

Most peoples provide something of a compromise in adapting traditional art to new subjects. The Indians of north-west America may make a near-realistic figure of the American or European personage but then carve on it typical symbolic eyes and eyebrows. The Eskimo uses his little pin-men shapes on engravings, distinguishing the

Europeans by their clothes, although he still sets them in the symbolic patterns of the arctic landscape. Similarly in African art, the local traditions are followed, and although costume is used as a distinguishing mark the proportions of a figure and the degree of realism are strictly within the local style.

The almost infinite variation in local artistic traditions makes classification extremely difficult. Probably the best approach is through technology. Naturally the conditions of the artists in a palaeolithic type of culture will influence the subjects of their art; and the use of tools of flaked stone and polished bone limit the number of techniques used in representation. We find the Bushmen were as expert in painting cave walls with a kind of crayon made of crushed natural ochres mixed with a little kidney fat as were the palaeolithic Europeans of two hundred centuries ago. They occasionally made bone pendants which were engraved with geometric designs scratched with a stone point, but their only representations of Europeans are of the mid-nineteenth century and are in paintings only. Among the Australian Aborigines we find a greater emphasis on geometric art, and although in quite modern times we find representations of ships on bark painting from Arnhem land, there is really nothing to show that the painters and engravers of that artistically gifted race had contact with or any artistic interest in the white settlers in the hunting grounds. However, the most advanced of modern palaeolithic hunters, the Eskimo, have shown great skill in making representations of animals and people. It is thought that some of the small hooded figures excavated from the Labrador regions may represent Norsemen from the Greenland settlements. Otherwise the majority of representations of the Europeans come from the west and north coasts of Alaska. They are scraped from ivory with the help of sharp stone blades set in wooden handles which reached from the hand of the carver to the inner surface of his elbow. Thus great and steady pressure could be exerted on the blade as it removed shaving after shaving of the tough natural ivory. After carving the required shape the artist smoothed the surface with a stone burnisher; later, when the work was finished, he would occasionally take the carving in his hands and polish and fondle it with pleasure. Such treatment gave to the works their wonderful surface quality and the yellowish tints which make old Eskimo ivories among the most attractive of all primitive sculptures. The engraved figures on bow-drills are more recent and are derived directly from the scrimshaw work

which the Eskimo saw in the hands of Russian, British and American seamen. By this time they were escaping from the limitations of the stone age and were able to use mounted nails and needles as tools for engraving. But a point polished into shape from one of the harder rocks would have served very well, and such a tool was probably used for engraving lines and occasional details on the older ivory figures. Most of this older Eskimo work has a beautiful and sensual quality in its forms and surfaces, but it hardly concerns us here since the European visitors do not appear until comparatively recent times.

The Indian tribes of the great plains of North America were a rather special case, since they continued to hunt in the late palaeolithic manner but also developed small-scale farming in river valleys. Their representations of the white men came very late in their history, when most of the tribal groups were already disorganised and moving westwards from the frontiers. Their rare woodcarving is not often found, and as far as we know there is no extant example depicting a European. The same appears to be the case with the red pipestone calumets. However buffalo robes provide examples in plenty. These are mostly of the mid-nineteenth century, when a nail might have been used for scratching outlines. In earlier days an outline could well have been marked with the point of an arrow, and slowly given strength by being traced over with a stick taken from the fire. Colours were mostly natural ochres, well rubbed into the surface of the soft tanned hide. The process was not difficult but somewhat tedious. However, its importance for social status made the labour and concentration worthwhile. Styles developed with time, but by the time white men are being depicted there is already an attempt to reproduce individual figures realistically, and the earlier symbolic human forms are no longer in evidence.

In the region of the north-west coast of America, the basic art form is painted sculpture, both in the round and in relief and often expressed in intaglio. Although the people lived in a pre-agricultural phase, their complement of tools was strictly neolithic in appearance. The highly polished stone adze was probably invented for chopping down trees before it became a tool of the wood carver. There were also rarer polished stone axe blades, but these seem to have been intended for weapons rather than tools. However, there were fine chisels of many sizes made from hard rock, and also thin blades lashed

to a hand grip which served as a kind of plane-like smoother. Technically, the carvers of this region had to understand the nature of their timber, since much of their best work was made from pine and cedar, and these timbers, with their rather strongly marked grain, have to be worked with care. Each cut must be directed to go through the grain in the right direction, since it is too easy to cut in such a way that large splinters are torn off. This is especially likely to happen when using heavy blows from an adze to rough out the shape of the carvings. The earlier work shows very skilled use of the adze and often presents interesting surface treatment where the strokes of the blade have broken off flakes of wood in an attractive pattern.

Of course, the arrival of the white man coincided with the introduction of steel knives, chisels and nails, so the first representations of Europeans show the influence of more efficient methods of cutting wood (plate 45), but the basic tool kit was just the same as in stone age times. One notices the difference most in small wooden figures where the later ones reveal a different kind of surface due to the use of a knife. Scrapers and routers were used for producing shallow relief sculpture on boxes and containers, but this medium gives few examples of the European in art. Mostly the figures of the white men are to be found in larger carvings, particularly on some fine mid-nineteenth-century totem poles. The style aims at realism and retains very little of the earlier formal symbolist design except in the details of eyes and fingernails.

A particularly interesting feature of north-west coast art is the appearance of carvings in argillite, a soft black shale which could be cut like cheese and which hardens and becomes brittle in a few days after exposure to air. Apparently this material was first found by sailors in the whaling ships and was used to good effect for a kind of chip carving (plates 51, 60). The Indian carvers soon adopted the new material, although at first their work is so realistic and so often represents Europeans with their houses and boats, that it seems as if the carvers had found a profitable tourist trade for their art.

However, after the first rush of work influenced by the white men, the styles again changed, and we find the totemic art expressing local ideas where clan and kinship become dominant. The appearance of magnificently sculptured slab-like tobacco pipes, oil bowls and dishes attests to the skill of the carvers in the new medium. In a later phase, objects of European origin were often carved on bowls and dishes, and small totem poles

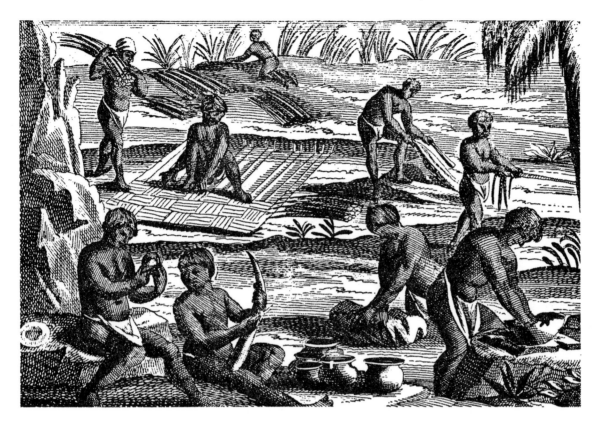

Sixteenth-century print of West African craftsmen carving ivory, weaving mats and making pottery

were made for sale to Europeans. In fact these last small carvings were a useful source of income in the sad days when Indian culture had almost totally broken down.

The best examples of sculpture of Europeans in the art of a fully neolithic, agricultural setting come from Oceania. However, they are rare and often hard to distinguish from the figures of divine beings in the old Polynesian arts. Formalism in these extremely traditional and aristocratic societies was totally dominant. Even among the New Zealand Maori, who were often in comparatively friendly contact with the settlers, ancient tradition insisted upon human representations in art being of the strictly formal style of the past. Technically the Polynesians as a whole were among the really great wood carvers of world history. Their polished stone adzes and chisels could be used to carve almost any required form. Some of the 'staff-gods', which represent ideas in abstract, three-dimensional forms of open-work carving, display a skill in the use of tools which was equal to that of many a master of the more civilised world, though their individual style puts them in a world of their own. The complex forms were polished with pads

of leaves dipped in sand and then by long and patient hand polishing. It is a pity that we have so little to show from this art style, but the tradition determined that it could not be used to show recognisably non-Polynesian figures. The few examples which have survived date from the latter half of the nineteenth century and present either figures with some semblance of European clothing, or carvings made for the mission churches.

In Melanesia, where neolithic villages abounded, we find much carving in soft wood, but the white man was not shown in art until the late nineteenth century. These Pacific islands were hardly exploited by the foreigners until the mid-nineteenth century. In the later phases we find engraved bamboo lime boxes with figures of soldiers, and the occasional carving of a white official protecting the contents of a canoe-house—this because of his association with magic. As usual the neolithic carvers began with simplified forms, possibly because the combination of shell and stone tools on wood make this the safest approach; but they developed towards realism under the influence of the European contact.

From the higher neolithic cultures of the Americas we have practically no possibility of representations of Europeans. By the time the people of Panama were making their pictures of angels with guns and appliqué blouses depicting ships and European tools, the ancient cultures had receded and local technology was that of any other small nineteenth-century village culture, where tools could be purchased from nearby stores. The Aztec artists, it is true, built magnificent early colonial churches in which their own qualities as artists and designers appeared, but this was after training in Spanish directed workshops. Similarly, the artists soon learnt the European device of perspective for illustration. In Peru we have nothing until after the Conquest, so that the church sculptures are very European in type, and the paintings also show European influence, though with a provincial charm which makes some of them very attractive works. The main source of Peruvian records of the white man are the wooden beakers with figures

IX Beauty on a palace terrace. The European ladies wear clothes made from elegant Indian textiles, but have not adopted the pretty trousers of the Indian maid servant. All wear rich necklaces to adorn the beauty of their bare breasts. Another servant wears a European boy's costume. Mogul style, late 17th century Indian painting. British Museum, London (1928. 8—15.05)

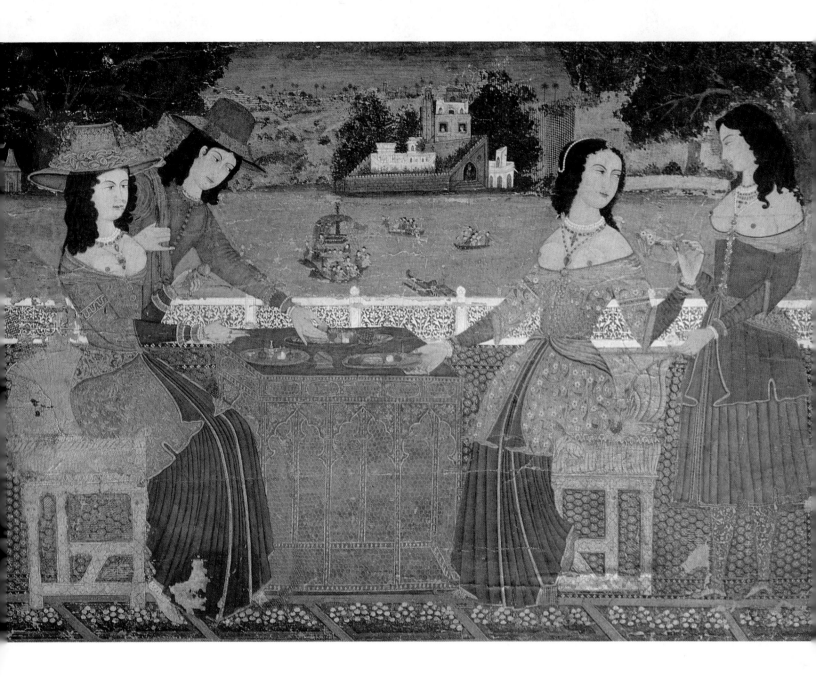

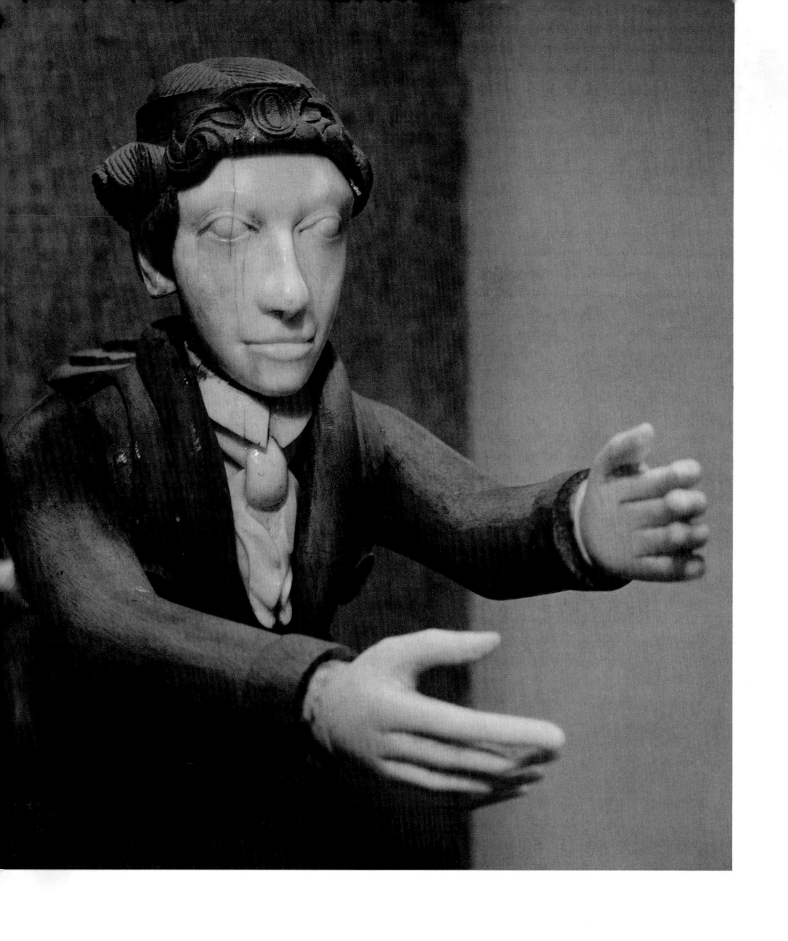

inlaid in coloured mastic (plate III). Some of these represent Europeans in the fashion of the day, but they should really be compared to the works of the Mestizo author Huaman Poma de Ayala, who while in Spain made an illustrated book containing our most authentic pictures of Pre-Columbian Peru. Even these, however, were made under European tutelage and with pen on paper.

Apart from the Bushmen, the whole of African Negro art comes from people already advanced in iron age technology. Everywhere tribal smiths knew how to extract iron and fashion quite efficient axes, adzes, chisels and knives fit for use by sculptors. They did not do much painting, except on the walls of huts in more settled regions, and their textiles do not seem to have included figurative work except in the large kingdoms of West Africa. Potters often modelled and incised heads, however, though full figures are comparatively rare (plate 14). African pottery, which was fired in a heap of brushwood over a fast fire, was usually very brittle and has seldom survived in any great quantity, though as early as the last century BC the potters of Nok in northern Nigeria were already very competent sculptors both of figures in motion and of large heads. The scope of African traditional sculpture is immense. The range of design from almost pure geometry, through symbolic form to realism is more complete than in any other continent, but the distribution of art forms is so complex that one cannot give typical regions for any given approach to sculpture. Tribal styles are within themselves very rigid and the transition of style from one tribe to another is usually quite abrupt.

The pastoral people of East Africa had very little figurative sculpture, though in pottery they made some very attractive vases and even statuettes. This occurs particularly in the important pastoral kingdoms of Uganda, where contact with Europeans produced a few particularly interesting black clay figurines. Also from the peoples of the Upper Nile there are a few figures carved in wood which include a famous one of the mous-

X Figurehead in miniature from an American Indian tobacco pipe. The carver has used cachalot ivory and cedar wood for this elegant little carving. The only trace of his native tradition is to be seen in the treatment of the eyes of the young man. By a confusion of types of figureheads seen on European ships the young man is given a headdress appropriate for a figurehead representing a classical goddess. Haida Indian carving, Queen Charlotte Islands, British Columbia. Early 19th century. Peabody Museum, Harvard (94/57 R. 195)

tachioed General Kitchener. On the whole the influence of Islam in East Africa led tribal artists to feel that the representation of human figures was somehow improper. Only in the inland regions mentioned above and among the peoples to the south do we find such representations. The figure sculpture of the AmaZulu with its massive blocking out of forms deteriorated in later times, and they, together with other South African Bantu people, still make a small income by the sale of carvings, including some of Europeans. Sometimes mineworkers from the great cities carve their wooden pillows with the new motifs derived from everyday events and street scenes. The modern carver's steel knife is sharper but it carves little better than the old hand-smithed iron blade of a century ago.

Of the central African kingdoms there is much to say because of the importance of court carvers whose work set a traditional style over large areas. In particular the people of Angola, and especially the BaKongo who lived around the hills and coasts from the mouth of the Congo southwards, were good sculptors with a tendency towards realism. They made contact with Europeans, mainly Portuguese explorers in the early sixteenth century, and later important Portuguese trading posts were established in their territory. Hence they had early opportunities for making representations of their visitors. It appears from many examples that the trader of the early nineteenth century was famed among the local artists for his addiction to strong drink (plate 47). One so often sees him sitting on a barrel with glass in hand and notes that he is shown with his hair and beard dressed according to the fashion of the time, which to Angolan eyes made him look rather like a monkey. On the ivory carvings one notes that the gangs of slaves are not often shown with Europeans in charge. The white trader was much more the shipper of human crops harvested by other hands. Sometimes the white man appears in an agreeable aspect and appreciates women (plate 17). On one pot he gently strokes a woman's breasts to their mutual pleasure.

In the great forests and grasslands which made up the vast hinterland of the Congo we find few artistic references to the European before the beginning of the century. There were few of them to be seen. Occasionally one sees an official, but the artistic triumphs in the field of representation of European things are religious images. Sometimes the figures for crucifixes and shrines, and sometimes priests and nuns are shown

with great simplicity, and without much influence from European traditions. In the Gabun the white man is made to conform to local styles and is sometimes distinguished from the fetish figures only by the fact that he wears a hat.

In all the central African regions the chiefs were sufficiently powerful to retain court carvers in their service. This influenced all the styles in the region practised by sub-tribes, who however managed to give a distinctive local tone to the common style. In the non-Bantu speaking kingdoms of West Africa, there were more highly organised societies, often strengthened by a great deal of trade through the European stations. The great West African kingdoms were socially organised to a high degree, and they were able to understand many of the ways, and the needs, of the strange creatures who came up from the sea in ships. The representation of the European is at first a matter of prestige to the local chief, and specialised carvers present us with a fine historical series.

There can be little question that in West Africa the appearance of the European trader caused a reorientation of trade. The old trans-Saharan trade which brought contact with the great Islamic states of the north was gradually reduced as the trade via the seaports increased. The great quantities of ivory available made the preservation of many carvings of Europeans a certainty, and today we can enjoy some fascinating representations of the Europeans of the early sixteenth century as they were seen in West Africa. Of course, one must remember that many of the Afro-Portuguese ivories were made by Africans brought to Portugal to be educated in the hopes that they would serve as preachers of Christianity to their relatives at home. They learnt European ways to such an extent that we find hunting scenes with deer and trees winding around Portuguese armorial bearings. Probably artists from Sierra Leone and perhaps the region south of the Gambia produced the earliest of such works. Later the ivory carvers of other tribes came into the trading network and we find lovely works which have a more eastern flavour probably from the regions of Dahomey and the Yoruba country including the city of Benin.

Throughout the West African region the ivory carvers worked by gradually scraping the figures from their pieces of hard raw tusk. The long-handled knife was used to ensure greater pressure and exact directional control of each thin shaving removed from the

surface. It was a slow process, and even when the work was almost finished there was still the long process of polishing with stone, sand, leaves and carefully greased hands to achieve a fine rich lustre. Somehow the West African carvers managed to achieve a quality of work which made ivory something like a fine pebble after a modern lapidary has worked on it. On the whole the western ivories of this group are simpler and more highly finished, while those from the Benin area tend to have much richer ornament and consequently less highly finished surfaces. The skill with which ivory was worked, including armlets made in two separate layers carved from a solid round section of tusk, approaches that of Chinese ivory work. It probably would have equalled it if the African artists had had lathes and drills instead of knives and awls. However, the African taste in design is marked and immediately recognisable in even the simplest pieces. It has a rhythmic sense which can only be compared to that of African music. There was in fact an artistic unity.

The art of casting bronze was probably old in several areas of West Africa before the appearance of Europeans. Possibly the technical skills had been learnt from the Arabs of North Africa, or perhaps they had descended from even earlier contacts across the Sudan grasslands with the kingdoms of Nubia. Certainly the Bini bronze casters (plate 4) learnt their work from the craftsmen of Ifé who had been making their remarkable near-realistic bronze heads of members of the royal family for some two or three centuries before the arrival of the Portuguese traders and missionaries. The methods used were the simplest possible, but being simple they required a high degree of personal skill in the technicians. In Benin these men were a highly respected guild of bronze workers attached to the royal court. They lived in a special area of the town and had their own social organisation. Their work was for the court only and their standards were the highest which could be achieved by their techniques. The raw materials, copper and tin for casting bronze, and also zinc, were to be obtained in Nigeria and many other parts of West Africa, but they would have had to be obtained by trade in Benin where the sources of supply were distant and beyond the dominions of the Oba (or king). In later times nearly all the metal used was already in the form of trade goods made of various alloys in the whole range of bronzes and brasses. One notes that from Ashanti have come a few large bronze ewers of English make of the late fourteenth and early fifteenth

century. It may be that these were old scrap metal brought to West Africa by merchants in the sixteenth century, but they could also have been earlier imports from along the trans-Saharan trade routes. Their very existence in one part of West Africa where fine bronze vessels were valued for their own sake, suggests that similar things may have been imported to areas where the local craftsmen used them as a source of raw material for re-casting in new forms.

The actual process of bronze casting in Benin consisted of a long period of preparation for a short period of casting and cleaning. A basic model was made of fire-clay and charcoal. This was overlaid by about 4 mm of wax on which all the details of the finished work were added, as extra strips where high relief was wanted, and by overall incising to give lesser details and the patterns on the clothing of the figures to be reproduced in bronze. This was painted over by several layers of fine fire-clay paste and then built up thickly to make a good strong mould. Wax rods penetrated the fire-clay investment at strategic points to act as pouring channels and vents. Then the whole block of fire-clay was heated gradually so that it would not crack, and the wax was poured out, to be used again later. Heating was continued and any residue of wax in the mould would be vapourised and burnt out. The hot mould was placed at an angle on a supporting earthen bank and kept hot during pouring. Crucibles of the molten alloy were taken by tongs and gently poured into the inlet passages to the mould. Hot fumes escaped, and gradually the molten metal appeared at the vents. All the time the pouring went on great care was taken, though not always successfully, to prevent air locks forming in the thin area of mould which was to be filled by the bronze. When all was done the mould was allowed to cool slowly. Then it was broken from the bronze cast which exactly filled the space first occupied by the wax model. The new metal figurine or plaque was then burnished, and details were chased wherever they had been obscured in the casting. Sometimes burn-outs and blowholes had to be carefully patched by pouring in new areas of bronze contained in a temporary fire-clay mould. When all was satisfactory the object was scrubbed clean, and in the case of a plaque, holes were punched in the corners, when it was ready for fixing on the wooden walls of the royal palace.

As time went on the craftsmen of Benin developed a stronger and heavier local style; they included figures of Portuguese soldiers and noblemen at their work, and

127

then slowly declined aesthetically, until just before the grim tragedy of the fall of Benin in 1897 the work had reached a very low ebb. In the early years of the twentieth century, bronze casting continued on a small and unimportant scale, since with no royal sanctions the members of the ancient guild had to consider only a very poor commercial market. However, in recent times their work has acquired new qualities and the ancient skills have been largely revived. In this book however we deal mostly with bronze work of the period when the Oba of Benin was making treaties with his Portuguese allies from over the great ocean.

Other West African kingdoms were centres of fine metalwork, and these included Dahomey where in later times many small brass groups were made. They are full of movement and have considerable beauty. They include several studies of European soldiers and statesmen. In the Cameroons, too, very fine brass castings were made in traditional styles. These often took the form of elaborately decorated bowls for huge tobacco pipes. Being large and heavy they were made to be balanced on the ground, and to take a long wooden stem for the convenience of the smoker. Apart from the production of masks and animal forms the technicians of the Cameroons could also make free-standing figures, and in the early part of the nineteenth century they produced the occasional figure of a European. The work shows no particular dislike of the foreigners; in fact some of them are friendly, happy pieces of work, representing individuals who were obviously liked by the artists.

North of the Sahara and throughout Asia the techniques available to artists were as rich as any known to Europeans before the Industrial Revolution. Except in Persia and Turkey, representations of the human figure were rare, though occasionally one does come across a painting in Persian style or a shadow-puppet figure. In the countries further to the east, technology was so advanced among specialist groups of craftsmen that there was practically no limit to artistic possibilities. One only has to think of the Mogul paintings (plate VII) and Ming pottery to realise that here were fields of artistic experience which had their own excellences quite on a par with the best works which could have been produced in Europe. The Indonesian islands were deeply influenced by neighbouring high cultures, though they were organised on the basis of an iron age culture not much more advanced than the central African states. Hand weaving

on simple looms and woodcarving in which chisels and knives were used sometimes represent European colonisers, but on the whole the influence of Europe was minimal. The cultures native to the islands had a strength which transcended the power of alien styles to develop in art. Perhaps the greatest influence is shown in the appearance of European objects and designs in some of the fine batik cloth from Java. The quality of this work depends on the technique and owes nothing to European influence except that the foreign motifs were sometimes found to be either profitable or attractive to the weavers and dyers.

We were their Models

Looking at the sculptures and paintings in this book affords a good deal of pleasure. The reason is quite simple, the artists were interested in their work and enjoyed expressing something special through it. They did not bother to consider aesthetics or scientific accuracy. Their aim was representation. Their method was to use whatever style was accepted by their fellows at the moment. The quality of pleasure comes from this clear unfussy presentation within the ambit of art forms other than our own. Some of these artists came from high civilisations and had trained under learned masters. They expended much time in practice and learning. Then, presented with the problem of making a representation of another human type, they called up all their professional skill and produced a fine work. In India in particular the elegance of late Mogul art blended excellently with the rococo style of eighteenth-century Europe. Chinese artists were not so free to use their own styles, since much of their best work was commissioned for the European market. They copied European works with marvellous precision, and modelled pottery figures with good humour because it paid well, and they did not become involved directly in Chinese art. The careful observation of the artist looking at his rare human models and the

much more plentiful samples of pottery for his imitation resulted in a certain quality of truth about us which is pleasing. One does not expect to earn approval for our curious manners and hideous vivid colours, but the artist shows us ourselves as we were. A study of Chinese figures of Europeans would tell us much more of the plain truth about Queen Anne and the gentlemen of her court than all the Chinoiserie in Schönbrunn tells of China. However, we may derive pleasure from the fact that our early reaction to Chinese art was in fact Chinoiserie. There was no such gay, lighthearted and really pretty style in all the rest of European art. It was false, but not a lie; it was simply a charming dream, and quite different from the remarkable factual approach of the Chinese artists of that day.

Japanese artists in the early days were as good as European ones, and they coped very successfully in small carvings and in painting with the problem of the white men and their God. But after the terrible breakdown of real understanding in the days of Hideyoshi, the great Shogun, a new aspect of the European comes to the fore. He is a funny thing, a long, skinny, bony creature with his long coat and long face. He has his dog beside him. Sometimes he crawls before authority; but it is not often that the European was taken very seriously by the artist, so we are not shown the degradation of those commercial-minded Hollanders who submitted to humiliation for the sake of commerce. The comedy of the strangers was noted in the delicacy of Japanese art. Their odd dress was not really disliked, but it was obviously amusing. Their solemn family groups were seen to be just like European furniture of the period, very upright and very uncomfortable. On the whole in the eighteenth century the Japanese found us funny in a rather pleasant way.

The nineteenth century was quite different. The Indians came under direct rule of the British Empire and made pictures of us which were not flattering, because, too often they were imitations of what the new white Sahibs wanted. It was not very real, and had none of the gusto with which Tippoo Sahib's tiger was made to maul the white

XI The white man and his wife. Two coloured carvings using local traditions, but with the features emphasised to show the narrow nose and small mouth of the European type. These may have been regarded as representations of powerful spirit beings. Painted wood carvings from the Cuna Indians of Panama Early 20th century. Peabody Museum, Harvard (24-39-20/F 455 and F 456)

soldier a century earlier. Indian art therefore was less free, but not angry at all. There was just a turning away from the old traditions to suit the tastes of the foreigner who, after all, paid quite well. In China the situation went downhill too. The unhappiness about the treaty ports and the forced submission of the Mandarins of a failing Chinese dynasty does not emerge from the paintings at all. They still show the European factually, and in a style of very delicate if decadent elegance. But they are no longer the portraits of anyone important. The white man buys curios in the market and if he pays well for a portrait; he gets one, but he has failed to deserve works of art. In Japan most of the nineteenth century went by without much note being taken of our kind of people. Then Commodore Perry and a number of other naval men backed by the black ironclads forced Japan to take note of the new world of commerce backed by might. The woodcuts show the events and the people very clearly, to form, perhaps, the most truthful historical record. The immediate effect was a study of Europe by Japanese artists. They depict the western world in their own way, and make it clear to our generation as no one else has ever done. We may see ourselves and our cities; the grime and smoke, the hustle, the occasional moments of sheer beauty, all appear in Japanese art. Conversely our own artists began to collect Japanese woodcuts and lacquer. Japan had retaliated through the arts and opened the world both ways with an effect which has not yet achieved its final stage in the development of beauty.

Of the other less complex civilisations there is a different story to tell. The impact on the Europeans in art was the acquisition of 'savage curiosities', and some things taken because they were made by the other peoples in European taste. It was not until the twentieth century began to develop that western artists realised that there were nonacademic ways of expressing fact in art. These things were shouting at them from African idols, Polynesian carvings and Indian totem poles. At last it was becoming possible for European art to assimilate the Renaissance and step forward into new realms of pictorial and tactile imagery. Savage curiosities became 'primitive' art

XII The girl and her sailor. She has filled his glass with saki from the bottle she holds. Yet even now she is somewhat nervous at the unrefined expressiveness of the strong barbarian man from over the sea. A Japanese colour print from a woodblock of the late 19th century. British Museum, London (1946. 4—13.010)

and joined in the half century of struggle to persuade the western world to accept new forms and rhythms.

We are shown, by the African, representations of Europeans in their health and power. The seventeenth-century impact of the white men in Africa was less important. Internal European quarrels disrupted the main enterprises, largely because the promotion of distant voyages was mostly under state control. When there was political imbalance the state was not willing to risk precious cargoes, and so the private traders had to take all the chances of the high seas including piracy. Africa was still very interesting, as we can see by the early collection of African and West Indian art in Ulm, the Weickmann Collection. The traders brought metal, cloth, beads, and furnishings as well as guns and gunpowder. They took ivory, slaves and gold. Trading posts were established and well fortified, since no one could tell when a local ruler might lose power and be overthrown by a less friendly neighbouring chief. French, English, Danish, and, in the latter part of the century, more Portuguese, came to trade in West Africa. The kingdoms inland were still powerful and there was much interest in a trade which was profitable and welcome to both sides.

The death rate among Europeans was appalling but the rewards of trade were great. It also becomes clear that some of the traders who were strong enough to resist the fevers found Africa a very beautiful land and the people interesting and friendly. The slaves were not local citizens but usually captives taken in war. The inhuman treatment accorded to them was sadly commonplace in the world of those times. Not many representations of Europeans survive in African art of the period. Some of the Benin bronzes show them in the costume of the mid-sixteenth century, but practically all the wood carvings have disappeared. The artists born in the land already had a well developed and ancient style of their own. It is certain that they made carvings of the strange elaborately clad traders, but alas the white ants have devoured the evidence.

The sad gaps in our knowledge of the development of African art styles is mostly due to the perishable nature of wood and clay. But these were the customary media of Africa, and, perhaps wisely, the past was left to become the dreamlike progenitor of the future. The present was visibly expressed and the tradition was in the hearts of the sculptors. In that way the sculptor Namba Roy after three centuries continued a

Bakongo tradition which he thought was individual, stimulated only by the family tradition that his ancestors had come three centuries before from the Congo. The special conditions of the BaKongo kingdom gave it a more satisfactory contact with the Portuguese in early times. The country was naturally healthy and the people active. Trading posts were set up, and early engravings show the king in seventeenth-century European costume among his state officials. Also some of the BaKongo artists worked in stone, and it is possible to understand how the arts developed through time from the formalism of the stone figures to the greater freedom of the wood carvings of the succeeding century. It was through the Bakongo that missionary influences first entered Central Africa.

Reactions to the missions were quite different in West Africa and Central Africa. In Benin the Christian church was accepted by a kind of treaty arrangement. We find it assimilates the royal cult as the years go by. Figures of Bini noblemen wearing crosses are not uncommon, but the great bronze crucifixes which early travellers reported seeing in the streets of Benin are no longer known to have survived. In the region of the Congo the religion was more fully accepted as a way of life, and we find that in the last century there were locally inspired religious carvings which are emotionally and artistically far ahead of contemporary European work. Sometimes one finds a missionary depicted in Yoruba carving, and we note that the early twentieth-century missionary is represented as the man with the book. By and large Christianity had small influence on the arts of Africa. Partly this comes from the association of the religion with the foreigner, and the difficulty in old Africa of thinking about a religion which extended far more widely than tribal and national boundaries. There was, moreover, the foolishness of many of the missionaries who were of the opinion that religious art must be entirely in a European tradition. There was really small place in African hearts for the sickly sweet pale representations of saints which were brought in. No sensitive person has ever found a true relation between the pretty plaster saints and the strong vivid personalities which were meant to illustrate heart-searching religious faith. Certainly the sensitive Africans must have found it strange when the missionaries explained that African art was wrong and this pseudo-ecclesiastical imagery was holy. In fact there must

have been much quiet laughter from people who could interpret the Christian faith better than the Europeans.

In the nineteenth century the arts of Angola really came into their own. The skilled carvers worked in many kinds of timber and had no hesitation in depicting the European in his funny aspects. Sometimes he is a foppish stranger very smartly dressed in the fashion of his day, sometimes he is a drunken trader, sometimes just a figure included in a carving as light relief. He is part of the scene in the town around the mouth of the Congo. The artists are not cruel to him, but sometimes one is aware of the laughter of Africa being more powerful than is expected.

The nineteenth century saw the development of imperialism and the subversion by foreigners of most African states. Consequently the artists show many of the respected deities of the Europeans like kings and queens and great generals. The complete disparity of power between the national groups made it difficult for the artist to see the conqueror as just an everyday part of the scene. It is his ceremonial status which becomes dominant. To us these works seem rather grotesque and unpleasant, because we find familiar figures from recent history in a new form. But the artists were depicting what they had seen the European treating with the greatest respect. It was not until the early twentieth century that African art again found the European to be human and friendly. All through West Africa we see ourselves as teachers, local officials, inspectors, soldiers, clerks, and very often as a comical crowd of curiosities. The laughter is usually of a friendly kind. But often the vices of the whites are suddenly displayed. It is strange to see the Europeans of the era when Freud was appalled by the results of their social inhibitions shown by Africans as sexually over-emphasised. Every now and then the white man is shown literally with his trousers down, and to the African it is not a joke but a characteristic of the libidinous foreigner. Of course we can now see in post-Freudian times that the sexually-active man is really suffering from inhibitions which were over compensated. We often called it living to a double-standard. But to the African it was very different from their much more natural attitudes on sexual behaviour and the conditioned proprieties of village life. We were very unnatural in their eyes. Still they often found us more friendly when it came to representations of unimportant people who were not starched by the social

hierarchy. If one separates the representations of the different colonising powers in Africa there is much to be seen of interest. French, British, German, Portuguese, we are all there, all with our special kinds of facial expression, and our different attitudes when in uniform or in mufti. African art was never very international in its attitudes, so we have pretty clear local impressions of ourselves in the regions where we were for a time the governing powers. Maybe to the African all the Europeans looked alike, but that led the artists to find a characteristic total quality for the group of Europeans with whom they were most closely linked. What they thought about the Europeans' imposed boundaries and political quarrels about African territories is not explained by the artists. In those days the artist was making direct statements and not embarking on the great ocean of ideas about world events. That was all to come later and it is not in this book simply because Africa is finding the road for Africans and representations of the European in art do not really matter much in the wonderful new world which is going through its first steps to new and truly African organisational ways.

Representations of Europeans from the countries which were basically neolithic in culture when we first encountered them are widely different. Sudden cultural changes bring about many emotional strains. In many parts of the world, but classically in the Pacific, we find a tribal neurosis which we label 'cargo cults'. In these the local people become convinced that the white man gained his wonderful powers by gifts of the ships' cargoes which he brought from the land of the ancestors beyond the edges of the sky. Eventually the enthusiasts would destroy their property and gather to some point where their prophets were assured that the ancestors would send them all they needed for a really happy modern existence. The white intermediary would no longer be needed. Alas! these visions too often led to rioting and collapsed in total failure, when the white men came in to renew supplies of food and offers of profitable work on the plantations. The idea of the cargo cult is important in art since it is inherent in the many representations of the fine things which the white man possessed. We find this in the carved ceremonial boards of the Andamans, in canoe houses in the Solomons and in an occasional betel-spatula in New Guinea.

In Polynesia there was a greater unity, but as we have seen the number of

recognisable pictures of Europeans is small. Later tourist art is no substitute for the first impressions of the early artists. The formulation of subjects is almost always fully Polynesian, and religious symbols from the missions are usually well integrated in Polynesian traditions. The compatriots of Gauguin influenced Polynesian art far less than Polynesia, seen with a romantic inaccuracy, influenced Gauguin and the world of the Parisian salons. Through them Polynesian art influenced the Art Nouveau, or Jugendstil, or Celtic Revival of Europe. Celtic Revival suggests that some of the artists were becoming aware that in the ancient tribal arts of Europe there was an inspiration somewhat akin to that of the new ideas coming from Japan, Africa and Oceania. To a few people the idea of the validity of non-classical inspiration was beginning to develop.

Native American representations of the European are rather limited in range. The Plains Indians showed some very grim truths about war and scalping, as well as pictures of raping expeditions by traders which led to battles. But this is all expression of the final stages in a long sequence of total incomprehension between the two peoples. In Panama the Cuna took trade catalogues from shops and developed appliqué patterns to decorate the pretty huipiles worn by the local girls. Some of their carvings show angels with guns, but that is perhaps a logical extrapolation of the texts in which the angels are described as powerful beings carrying swords of fire. The dressing in European costume gives the idea of the social dignity of these angels, just as the Creoles of European descent in their European clothes were socially better off than the Cuna in their little semi-independent coastal villages. On the Northwest Coast it was quite different. The Europeans and Americans were at first seen as equals with their own magic, which was only of the same order as that of the local totemic system. Trade was quite free and many a Tlinkit or Haida found himself in the crew of a whaler among Polynesians. The turn of Northwest Coast Art to the making of trinkets for tourists marks the breakdown of the ancient culture after about 1860, but it never lost its old qualities entirely. However, it was not to develop like the rather specially new and artistic work produced by modern Eskimo artists, who have developed as the old Eskimo culture has reached its final break with traditional life.

Conclusion

Thus they saw us! It is rarely an expression of theories but factual observation which informs the artists whose work is represented in our book. We may find much comment on ourselves and our developing civilisation as we go through the historical sequence of the works of art. We find that on the whole we have been observed with friendly eyes and with not too much respect. Wherever there has been direct imitation of our styles there has been an intellectual barrier which results in poor artistic quality. Wherever we have been treated as strangers seen through the style of the local artists then we assume life.

Having assumed life we find that we have strange aspects as formalists wearing special clothes, as erotic cranks, as noble spirits, as powerful warriors, and occasionally as kind and gentle missionaries. But everywhere there is the implicit feeling that we are observed with eyes which are free from our own particular optical delusions. 'Primitive' art is not really primitive; it is a local interpretation of form varying according to custom. Not usually rationalised it is always instinctively sound. When it takes the European as a subject, special problems arise. How should the artist interpret a being so different in culture and costume from his own people? Should he invent a special tradition, or interpret by symbols known to all? How far should he alter his style to please the foreigner who will pay him what he regards as a good price for his products. So the way in which we are represented varies enormously.

Thus we have, we hope, opened a little path of understanding. We should try to understand ourselves as seen in these unusual mirrors of other men's minds and yet also see that these others are like ourselves in so many ways. In the world of the inner personality there is a bridge between all artists of all races, and one must hope that with its enlargement into the sphere of intellectual understanding more and more people will begin to understand the unity in diversity which is the race of Man.

Select Bibliography

GENERAL:

Burland, C. A.: Man and Art (Studio Publications).
London 1959
Europa und der Kolonialismus (*W. Ruegg*).
Zürich 1962 (containing the chapter by *P. Meyer:*
Beziehungen des Kolonialismus zu den bildenden
Künsten).
Hooper, G. H. and C. A. Burland: The Art of
Primitive Peoples. London 1953
Lips, J.: The Savage hits back (H. A. Humphrey).
London 1937
Die überseeische Welt und ihre Erschließung
(Historia Mundi, *Fritz Valjavec*, 8th vol.).
Bern 1959

AFRICA:

Afrika (Handbuch der angewandten Völkerkunde,
2 vols, *Hugo A. Bernatzik*). Munich 1951
Bodrogi, Tibor: Afrikanische Kunst. Vienna 1967
Fagg, William B.: African Tribal Sculpture.
2 vols. London 1967
Frobenius, Leo: Kulturgeschichte Afrikas. Vienna
1933
Himmelheber, Hans: Negerkunst und Neger-
künstler. Braunschweig 1960
Kjersmeier, Carl: African Negro Sculptures.
Copenhagen 1947
Westermann, Diedrich: Geschichte Afrikas. Cologne
1952

AMERICA:

Burland, C. A.: North American Indian Mytho-
logy. London 1966
Disselhoff, H. D.: Geschichte der altamerikani-
schen Kulturen. Munich 1953
Friederici, Georg: Der Charakter der Entdeckung
und Eroberung Amerikas durch die Europäer.
3 vols. Stuttgart–Gotha 1925–1936
Schaeffer-Simmern, H.: Eskimo-Plastik. Kassel 1958
Siebert, E. and W. Forman: North American Indian
Art. London–Prague 1967

OCEANIA:

Beaglehole, J. C.: The Exploration of the Pacific.
London 1934
Guiart, J.: Arts of the South Pacific. London 1963
Poignant, Axel: Oceanic Mythology. London 1967

ASIA:

Beamish, Tony: The Arts of Malaya. Singapore 1964
Dick, S.: Arts and Crafts of Old Japan. London
1904
Dunbar, G.: Geschichte Indiens. Munich 1937
Eberhard, W.: Chinas Geschichte. Bern 1948
Graaf, H. J. de: Geschiedenis van Indonesië. The
Hague 1949

Grünwedel, Albert: Buddhist Art in India. London
1965
Mookerjee, A.: The Arts of India. Calcutta 1966
Needham, Joseph: Science and Civilisation in China.
London–Cambridge 1964
Newman, A. R.: Japanese Art. A Collector's
Guide. London 1964
Reichwein, A.: China und Europa. Berlin 1923
Siebold, Ph. F. v.: Nippon. 3 vols. Berlin 1930-31
Tsuzumi Tsuneyoshi: Die Kunst Japans. Leipzig
1929
Villiers, J.: Südostasien vor der Kolonialzeit.
Frankfurt/M 1965
Watson, William: Early Civilisation in China.
London 1966

COLONIALISM:

De Kat Angelino, A. D. A.: Colonial Policy.
2 vols. The Hague 1931
Duffy, James: A Question of Slavery. Oxford 1967
Fieldhouse, David K.: Die Kolonialwerke seit dem
18. Jahrhundert. Frankfurt/M 1965
Girault, A.: Principes de colonisation et de
legislation coloniale. 4 vols. 5th Edition. Paris
1927–1933
Hunter, Guy: South East Asia. Race, Culture and
Nation. London 1966
Klein, Herbert S.: Slavery in the Americas.
London 1967
Labouret, H.: Colonisation, colonialisme, dé-
colonisation. Paris 1952
Meek, C. K.: Land, Law and Custom in the
Colonies. London 1946
Metge, Joan: The Maoris of New Zealand.
London 1967
Rein, Adolf: Die europäische Ausbreitung über
die Erde. Potsdam 1931
Rolland, L. and P. Lampue: Precis de Droit dé
Pays d'Outre-mer. Paris 1952
Ryckmans, P.: La Politique Coloniale. Paris 1933

VOYAGES AND DISCOVERY:

Armstrong, Richard: A History of Seafaring.
London 1967
Clark, William R.: Explorers of the World.
London 1964
Debenham, Frank: Discovery and Exploration.
London 1960
Hapgood, Charles H.: Maps of the Ancient Sea
Kings. Philadelphia 1966
Ortelius, Abraham: Die schönsten Karten aus dem
Theatrum Orbis Terrarum. Hamburg 1967
Plischke, Hans: Entdeckungsgeschichte von Alter-
tum bis zur Neuzeit. Leipzig 1933